Collecti1
Edgar Rice Burrougns

Glenn Erardi

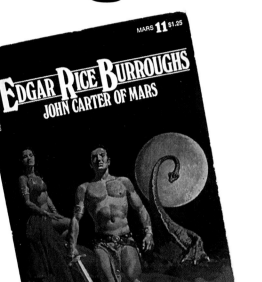

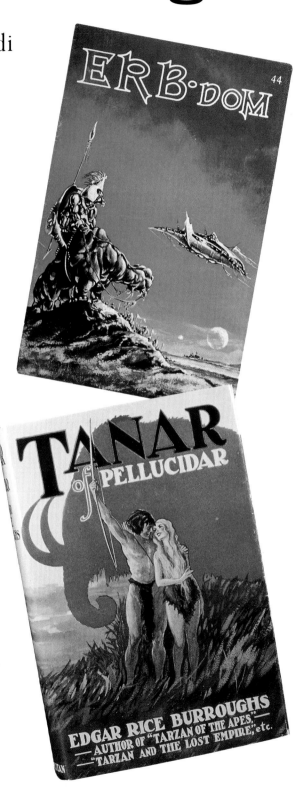

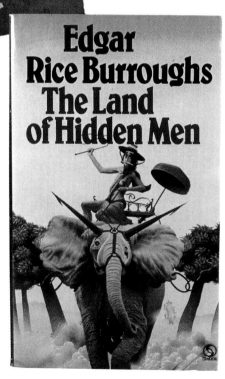

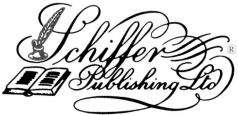

Schiffer Publishing Ltd®

4880 Lower Valley Road, Atglen, PA 19310 USA

Dedication

This one is for James Walter Duff Erardi.

The following characters, trademarks, and names are owned by Edgar Rice Burroughs, Inc.:

"Tarzan"
"Barsoom"
"John Carter"
"John Carter, Warlord of Mars"

Edgar Rice Burroughs, Inc. did not authorize this book nor furnish or approve of any of the information contained herein. This book is derived from the author's independent research.

Designed by Bonnie M. Hensley
Type set in Windsor BT/Zapf Humanist 601 BT

ISBN: 0-7643-1101-8
Printed in China
1 2 3 4

Published by Schiffer Publishing Ltd.
4880 Lower Valley Road
Atglen, PA 19310
Phone: (610) 593-1777; Fax: (610) 593-2002
E-mail: Schifferbk@aol.com
Please visit our web site catalog at
www.schifferbooks.com

This book may be purchased from the publisher.
Include $3.95 for shipping. Please try your bookstore first.
We are interested in hearing from authors
with book ideas on related subjects.
You may write for a free printed catalog.

In Europe, Schiffer books are distributed by
Bushwood Books
6 Marksbury Avenue
Kew Gardens
Surrey TW9 4JF England
Phone: 44 (0)208-392-8585; Fax: 44 (0)208-392-9876
E-mail: Bushwd@aol.com
Free postage in the UK. Europe: air mail at cost.

Contents

Acknowledgements

All books are collaborative endeavors, even if they don't appear to be—no one writes a book alone. Below are some (but not necessarily all) of the people who helped with this book; my thanks to all for their contributions.

George T. McWhorter, Curator, Edgar Rice Burroughs Collection, Ekstrom Library, University of Louisville, Louisville, Kentucky; without his cooperation and inspiration this book would only be an incomplete thought, instead of a reality.

ERB fan Bob Mosher once again opened his door to me; but only after he chained Tarzan, his dog, to a tree outside.

Nancy Erardi said that I could do it . . . and she was right.

Peter Schiffer gave me an opportunity and then repeated the gesture several more times.

Douglas Congdon-Martin, editor, for answering the phone.

The readers (nearly 3 million weekly) of *THE COLLECTOR*, whose questions keep me on my toes.

Finally, each and every ERB/Tarzan fan and reader who commented on *Guide to Tarzan Collectibles*.

Introduction

This modest book is intended as a reference guide to the non-Tarzan works of Edgar Rice Burroughs (1875-1950). ERB (as he's often called by fans) was the creator of Tarzan® and a "Founding Father" of American Science Fiction, and his legacy as one of the most published writers of all times (it's been said more than once that *Tarzan of The Apes* is the most published novel in the English language) cannot be disputed. His wondrous tales have inspired generations of dreamers, mind-travelers, and even some famous writers. I hope to be able to introduce at least one potential ERB fan to *The Master's* many worlds; whether it's the Old West, Mars, Venus, or the interior of the Earth.

In a long writing career, ERB knew success and fame, attaining great wealth along the way. His agile mind leaped from tale to tale: visiting planets, plains, and Pellucidar. Burroughs' characters and tales have appeared in newspapers, comic books, movies, and were even translated into dozens of languages. For generations, the great illustrators have made their mark by depicting the landscapes and creatures of Burroughs' imagination. From St. John to Jusko, hundreds of artists have helped "flesh out" ERB's fantasies.

A Brief Burroughs Bio

Born in 1875, Edgar Rice Burroughs was the youngest child of George and Mary Evaline Burroughs. A prosperous businessman, George had served as an officer with the Union army during the Civil War. Mother Mary could trace her lineage back to the earliest European settlers.

Edgar spent an uneventful childhood, until as a thirteen-year-old he was sent west to stay with an older brother, in order to escape one of the epidemics that frequented his hometown of Chicago. The experience of days in the saddle, riding fence, helped stamp the man he would later become; he was developing skills that he would later attribute to his novel's heroes.

It was probably at this time that his storytelling proficiency first appeared. Hours of romantic daydreaming among the wide skies and unpopulated areas that he roamed helped the young boy create the tall tales he shared with others around the evening campfire.

Young Edgar eventually returned to Chicago and school, only to find that his father had enrolled him at prestigious Phillips Academy at Andover, Massachusetts. Not having been a good student to begin with, Edgar was thrown out after only one semester—but not before being elected class president first. Unfortunately, he didn't put as much effort into studies, and in later years (after becoming a millionaire from his writings), said that formal education had been wasted on him.

Knowing that his son needed a firm hand on his reins, George Burroughs next enrolled him at the Michigan Military Academy. At Michigan, Edgar matured into a first-rate student. The regimen and military education, focusing on those skills that Edgar had already

Edgar Rice Burroughs (1875-1950)

developed during his stay out west, finally paid off. He excelled in riding, shooting, and other activities that relied on physical abilities. He even did very well in more formal studies.

Upon graduation, his father, pulling some strings, got him an appointment to West Point. Edgar rode the trains east, sat for the examination and failed it miserably. In shame he returned to his family in Chicago to find that his former school at Michigan was willing to hire him as an instructor . . . of geology.

After a year on the teaching staff, feeling that he fit in with neither the students nor instructors, Edgar enlisted in the Army to pursue his goal of a military career. He hoped to rise through the ranks and become an officer, as had his father.

He was sent as a private soldier at age nineteen, in 1895, to serve in the cavalry against the Apaches in Arizona. The experience turned out to be another disappointment. Most of the time, the soldiers were not gallantly fighting the "noble" Indian foe; instead, they built roads, dug ditches, and basically applied themselves to hard labor in the Arizona desert. Again, the senior Burroughs pulled some strings and got Edgar out of the service on a medical pretext.

Once more Edgar returned to Chicago in disgrace. Taking a menial job in his father's enterprise, he settled down to the start of a middle-class existence. He even married the girl he'd been courting since his early teens, Emma Hulburt.

The next dozen years would see Emma and Edgar moving from one state to another. Chasing schemes and dreams, Edgar began a series of low paying and short-held jobs: dredging for gold with his older brothers, operating a stationery store, rousting railroad bums as a policeman. He was hired by the giant catalog retailer, Sears, and had he been willing to stick with it, could have eventually risen within the firm to prominence. This was not to be. Edgar just couldn't tough out these jobs. He always wanted the quick route to fortune.

In 1911, within a few weeks of his thirty-sixth birthday, Edgar was a failed man. Unable to feed his feed his wife and three children, deeply in debt and involved in a new venture selling pencil sharpeners (which no one bought), he decided to pass the times writing a story for the pulp magazines that were popular at that time. Who knows, maybe he could even make some money?

Edgar had no training in formal writing. Even after he became one of the most famous and wealthy authors of all times, his writing techniques were unsophisticated. But could he tell a story! And that's what he did in his first published tale, *Under the Moons of Mars* (book title, *A Princess of Mars*), a fantastic adventure set on a distant planet, with all the features of what is now called "science fiction," a phrase that has been attributed to Burroughs himself.

Since Edgar was a novice and had no idea of how the publishing business was run, he demanded that all but first publication rights be returned to him. In those days an author sold his story outright, and generally received a single payment for all rights. Early on, Edgar realized that stories could appear in media other than print. These actions on his part would have an effect on the publishing industry that is felt even now. All authors who came after Burroughs can be grateful that he was so far-sighted.

ERB (one of the very few writers who is recognized by initials alone) made only $400 for this first story. It was featured in *All-Story Magazine*, as a serial (a common practice, since readers would buy the next issue if a story caught their interest) from February to July 1912. From this point on, Burroughs wrote approximately two and a half books a year until his death. Because his first story line was so fantastic, ERB initially used the pseudonym "Normal Bean," impishly implying that he was not a *crazy* fellow ("bean" being then current slang for head, and by extension, mind). As luck would have it, a typesetter figured the name for a typo and changed it to "Norman Bean." After that, except for several pieces, Burroughs wrote under his own name.

He penned *Tarzan of the Apes* in 1912, and it too was serialized in magazine form, as would be almost all of his stories. This one story alone probably would have secured his place in the history of literature, yet he went on to produce story after story for nearly forty years.

Along with the many more novels he would write, ERB would control a financial *empire* fueled by the creations of his imagination—the first such author to mass-market his works. He also witnessed the bombing at Pearl Harbor and became World War Two's oldest war correspondent. He died in 1950 and his remains were buried at his estate in Tarzana, California—a town named after his most famous character.

The Present and Future of ERB

Today, most of ERB's works are still in print. In fact, it's possible that a greater number of books have been published after his death than were produced during his lifetime. Other writers have completed several unfinished novels found among his papers after his death. Along with the original stories that have been translated into many languages, there have been *pastiches* written in homage: some by fans, some by top authors, some by both. And for the greater part of a

century, whole schools of illustrators have cut their teeth on Burroughs, many returning time and time again to restate their respect for this master story-teller.

While there are no lack of movies based on Tarzan, many fans have bemoaned the dearth of movies derived from Burroughs' other works. It's recognized that film makers in the past have been limited in their ability to reproduce the landscape, peoples (if that's the proper word to use), denizens, and action that ERB described in his Mars, Venus, and Pellucidar series, to name a few. Perhaps with the new computer/digital technology, that can finally be corrected and we will see a sword-wielding John Carter in Technicolor with Dolby stereo. Who knows? Until then, I guess we'll have to be content with using the "camera of the mind" to view the exploits of *The Warlord of Mars*.

Earlier, I stated that I hoped this book would act as an introduction to Burroughs for new fans. Maybe, just maybe, someone would pick up one of ERB's books, read it, and become *hooked*, as I was, and as millions of others have been. Not only is the reading of ERB's works important, I think the new *Burroughsophile* should also have access to other fans. With that in mind, at the back of this book readers will find a list of some of the Edgar Rice Burroughs fan groups.

Organization

When assembling the items to photograph for this book, I considered both the serious and novice collector's need and wants. While it's a difficult feat to please one while not neglecting the other, I have attempted (in the space allowed) to provide as varied a view of ERB collectibles as possible. I realize that some things will be left out; but that's almost inherent in this type of guide.

To give the book some semblance of order I decided to start at the beginning, as it were, and since most of ERB's stories first saw the light of day in *pulp* magazines, then that's where each category will commence. After that will come, in succession: hard cover, paperback, comics/comic book, magazine/fanzine, foreign editions (hard, paper, and magazine), trading cards, any movie related items, toys, etc. Some of these steps may not appear. Not every collectible is available in each category. Again, the inclusion of fanzines (also listed in *Guide to Tarzan Collectibles*) is meant to show the mounting interest in the collecting of these fan-driven periodicals. Fanzines have been in print for decades, and some of their prices now exceed those of other more traditional collectibles.

I've decided not to include story synopses; limited space will not allow that. The reader can find most, if not all, of these works at his or her local library or bookstore. Additionally, many works in their entirety have been posted on the Internet. This will give the new fan a chance to visit with—for the first time perhaps—John Carter or David Innes, while the long-time aficionado can once more journey to Caspak or Pellucidar.

When it came to organizing the contents of this book, some stories, such as the series on Mars, Venus, and Pellucidar, naturally fell into their own separate categories; other works, being less defined or of a non-serial nature, ended up sharing chapters. Then again, some stories can fit into several chapters. In that case, I decided to avail myself of the universal decision making strategy . . . the toss of a coin.

The reader may admit to some confusion regarding the differing titles on some works (I'm sure that even ERB had a difficult time keeping the various stories in order), so I have listed the works (using the book title) at the beginning of each individual chapter by chronological order. In other words, the first book written heads the top of the list. Another point of confusion stems from the fact that some books didn't see print until long after Burroughs' death. And to add to the chaos, copyright and printing dates are sometimes omitted, especially in the paperbacks. One further point of confusion is the practice of some publishers to *marry* unrelated titles, such as *The Land that Time Forgot* (&) *The Moon Maid* by Dover.

Prices

Prices are based on the compilation of a sampling of current retail, auction, price guide, and fair market values. Most items illustrated are in very good condition, as reflected by the value assigned. As with any collectible, condition is one of the keys to assaying worth. The better the condition, the greater the value. Rarity also plays a great part in determining cost. In most examples the price is expressed in a range, showing high and low values for that particular item. In some instances the item pictured will have a fixed price; such is the case of the trading cards, which due to their relative newness and availability, have not yet experienced a noticeable increase in value. Also, several books, still in print, are not range-priced.

Comments may be sent to:

Glenn Erardi
PO Box 878
North Andover, MA 01845-0878

Chapter One
Venus

Pirates of Venus
Lost on Venus
Carson of Venus
Escape on Venus
The Wizard of Venus

While not as fully realized as his *Mars* series, and written later in his career, the *Venus* tales are nonetheless a very interesting grouping created by Burroughs. One of the books was actually published in 1964, fourteen years after his death.

The hero of these stories, Carson Napier, was named after a fellow who served with ERB at Fort Grant, Arizona. Many of ERB's stories would feature names from real-life acquaintances, or places that Burroughs visited or lived.

Pirates of Venus

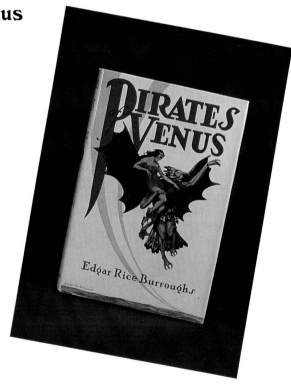

Pirates of Venus, hardcover, Burroughs, February 15, 1934 (cover by J. Allen St. John). $450-$600

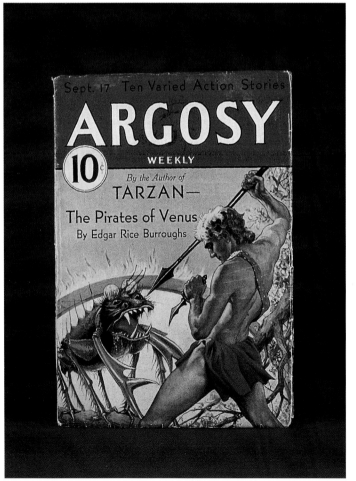

Pirates of Venus, pulp magazine, *Argosy Weekly*, September 17, 1932 (cover by Paul Stahr). $45-$55

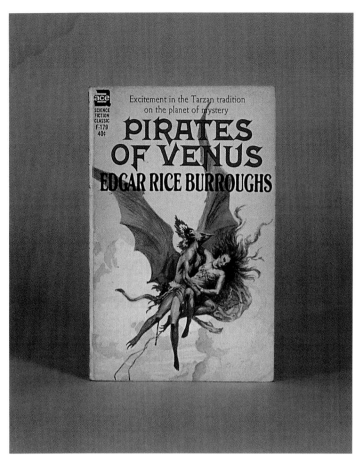

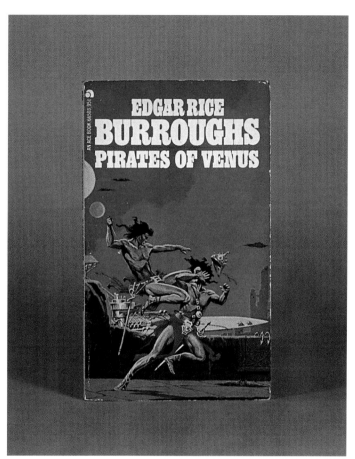

Pirates of Venus, paperback, Ace #F-179, undated (cover by Roy Krenkel). $7-$9

Pirates of Venus, paperback, Ace #66503, undated (no art credit - Krenkel?). $5-$7

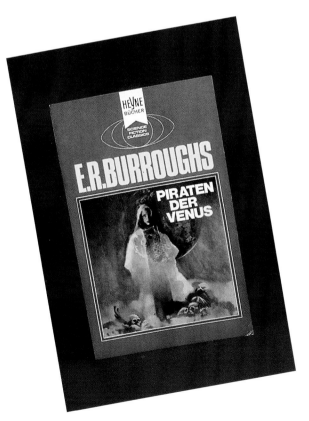

Beasts of Venus, trading card, Comic Images, 1993 (art by Frank Frazetta). 15 cents

Pirates of Venus (PIRATEN DER VENUS), German paperback, Heyne, 1972 (cover by Jeffrey Jones). $9-$12

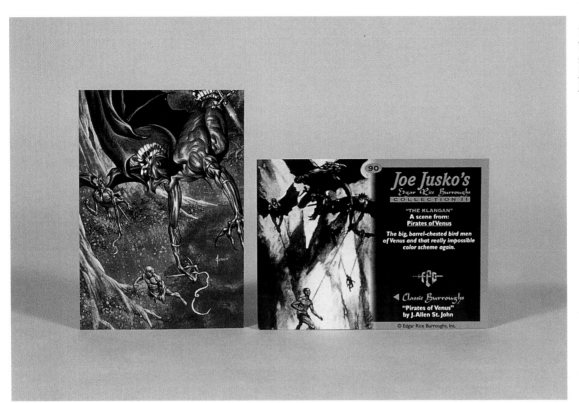

The Klangan/Pirates of Venus, trading card (both sides), FPG, 1995 (art by Joe Jusko & J. Allen St. John). 25 cents

Lost on Venus

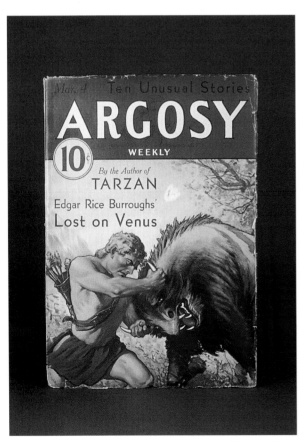

Lost on Venus, pulp magazine, *Argosy Weekly*, March 1933 (cover by Paul Stahr). $45-$55

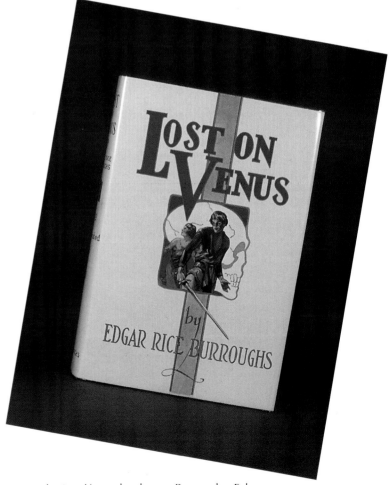

Lost on Venus, hardcover, Burroughs, February 15, 1935 (cover by J. Allen St. John). $350-$550

Lost on Venus, trading card, FPG, 1994 (art by Richard Hescox). 15 cents

Carson of Venus

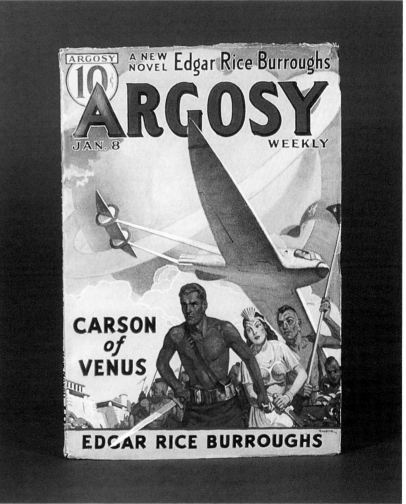

Carson of Venus, pulp magazine, *Argosy Weekly*, January 8, 1938 (cover by Rudolph Belarski). $45-$55

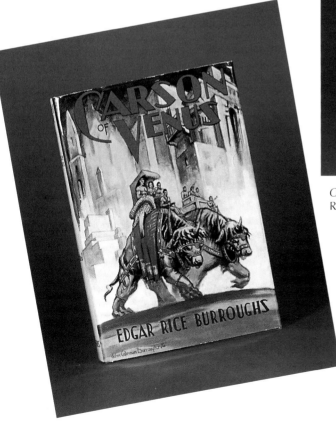

Carson of Venus, hardcover, Burroughs, February 15, 1939 (cover by John Coleman Burroughs). $300-$500

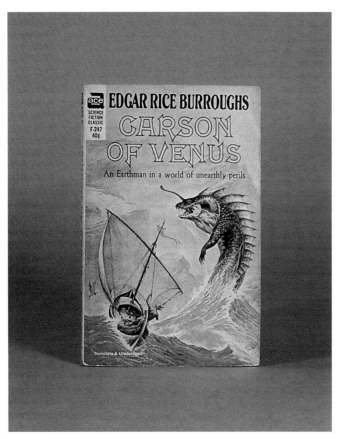

Carson of Venus, paperback, Ace #F-247, undated (cover by Frank Frazetta). $7-$9

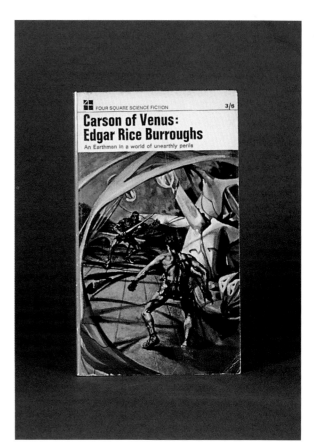

Carson of Venus, British paperback, Four Square, January 1967 (no art credit). $8-$10

Carson of Venus, trading card, Comic Images, 1991 (art by Frank Frazetta). 15 cents

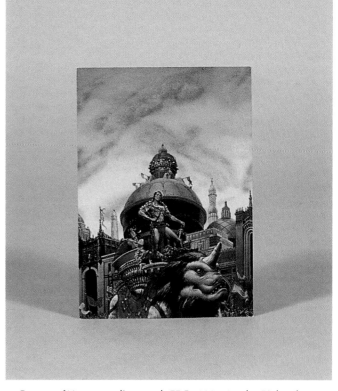

Carson of Venus, trading card, FPG, 1994 (art by Richard Hescox). 15 cents

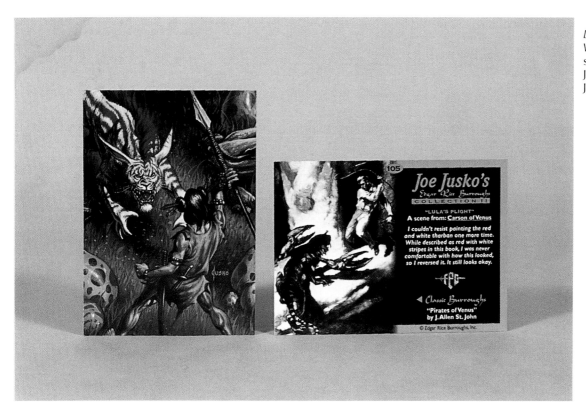

Lula's Plight/Pirates of Venus, trading card (both sides), FPG, 1995 (art by Joe Jusko & J. Allen St. John). 25 cents

Escape on Venus

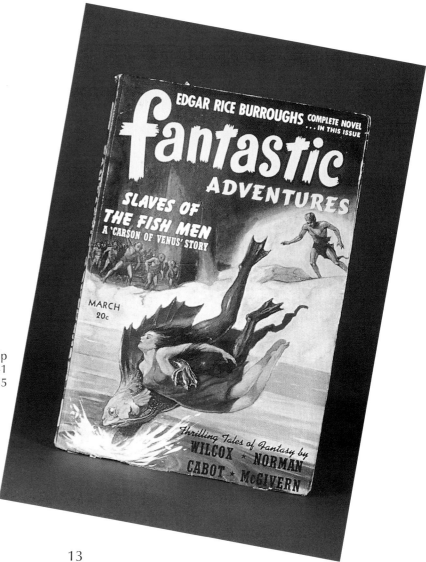

Slaves of the Fish Men (*Escape on Venus*), pulp magazine, *Fantastic Adventures*, March 1941 (cover by J. Allen St. John). $45-$55

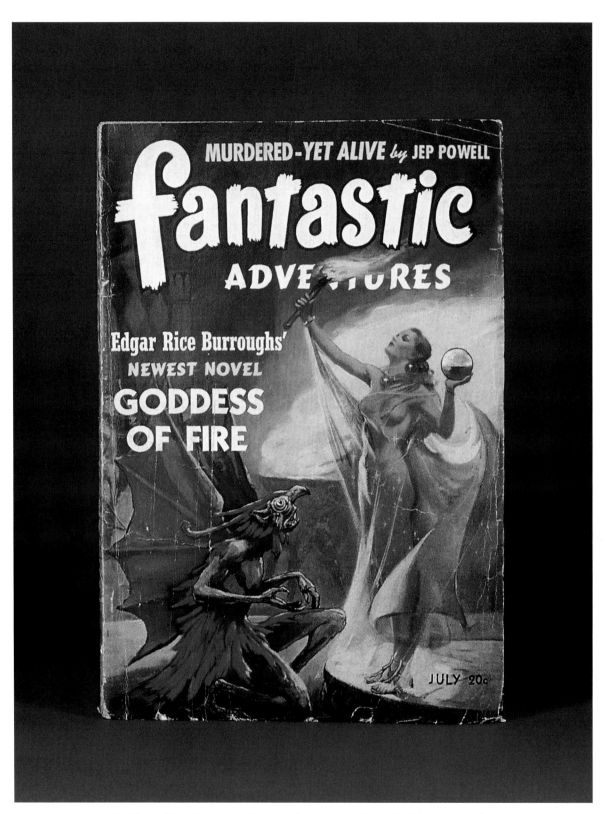

Goddess of Fire (*Escape on Venus*), pulp magazine, *Fantastic Adventures*, July 1941 (art by J. Allen St. John & H.W. McCauley). $35-$45

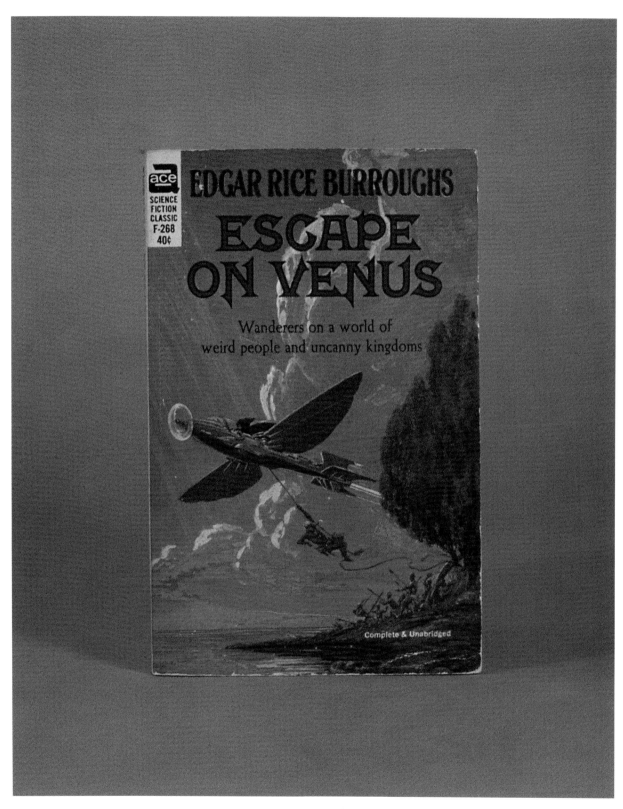

Escape on Venus, paperback, Ace #F-268,
undated (cover by Roy Krenkel). $7-$9

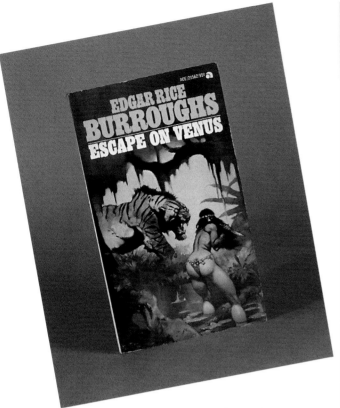

Escape on Venus, paperback, Ace #21562, undated (cover by Frank Frazetta). $6-$8

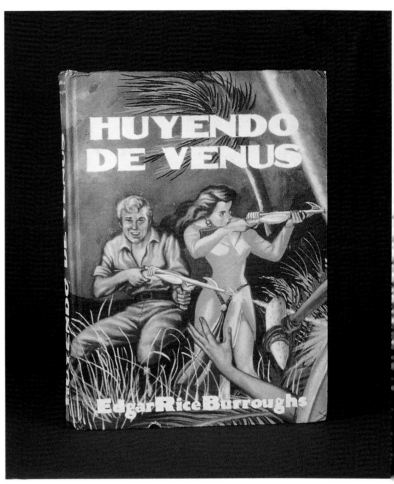

Escape on Venus (HUYENDO DE VENUS), Spanish hardcover, limited to 5,000 copies, Helios, 1955 (no art credit). $12-$15

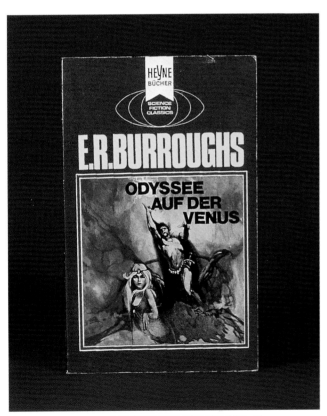

Escape on Venus (ODYSSEE AUF DER VENUS), German paperback, Wilhelm Heyne, 1972 (cover by Jeffrey Jones). $7-$9

Escape on Venus, trading card, FPG, 1994 (art by Richard Hescox). 15 cents

The Wizard of Venus

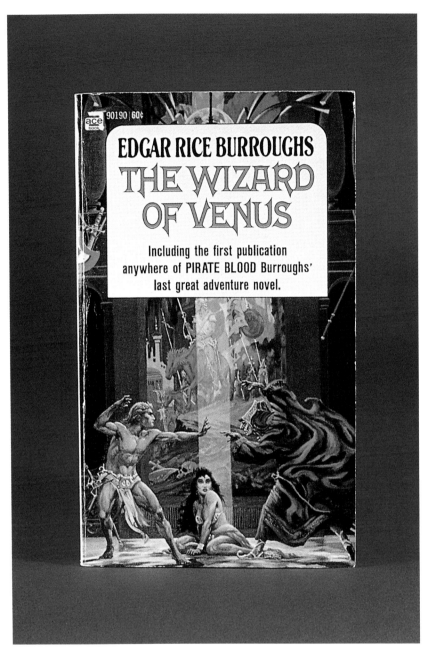

The Wizard of Venus, paperback, Ace #90190, August 1970 (cover by Roy Krenkel). $5-$7

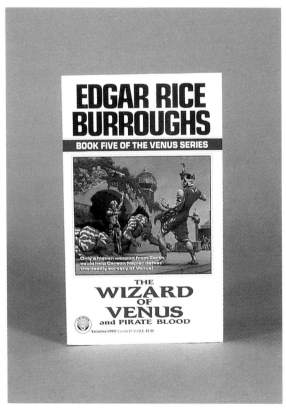

The Wizard of Venus, paperback, Ballantine #37012, 1991 (cover by Roy Krenkel). $4-$6

Chapter Two
Pellucidar

At the Earth's Core
Pellucidar
Tanar of Pellucidar
Tarzan at the Earth's Core (see Guide to Tarzan Collectibles)
Back to the Stone Age
Land of Terror
Savage Pellucidar

The *Pellucidar* series is perhaps one of the most exciting and exotic cycles produced by ERB. In these books we can see evolution (Burroughs-style) at constant work. In Pellucidar we meet memorable characters and unforgettable horizons.

From ancient times, writers, fascinated by the concept of a hollow Earth, let imagination (and logic) run wild, creating landscapes and monsters galore. But none before or after Burroughs created a work of such epic proportions.

A favorite with illustrators, Pellucidar offers readers alien, yet familiar landscapes and peoples, high adventure, action, and romance.

At the Earth's Core

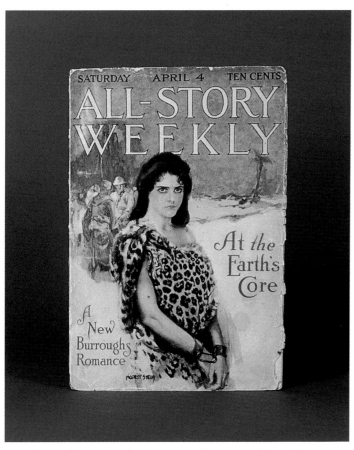

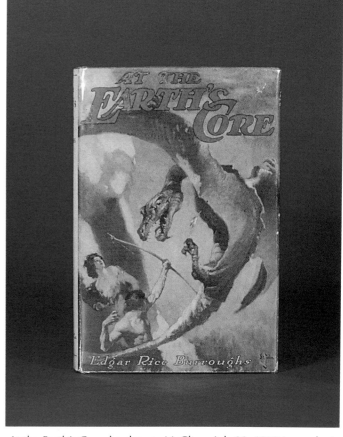

At the Earth's Core, pulp magazine, *All-Story Weekly*, April 4, 1914 (cover by Modest Stein). $180-$220

At the Earth's Core, hardcover, McClurg, July 22, 1922 (cover by J. Allen St. John). $1,300-$2,200

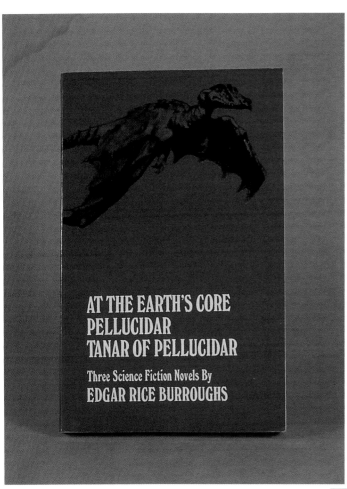

At the Earth's Core/Pellucidar/Tanar of Pellucidar, trade paperback, Dover Books, 1963 (cover by J. Allen St. John). $12-$15

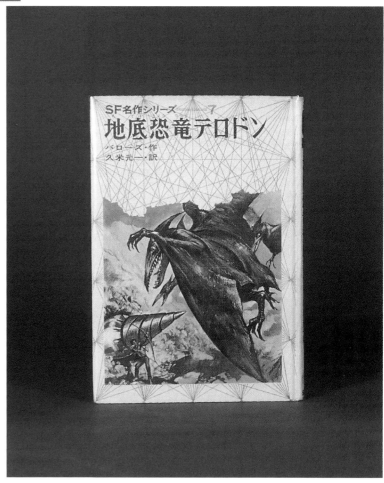

At the Earth's Core, Japanese hardcover (reads right to left), Nihonsha, 1967 (cover by Motoichiro Takebe). $12-$15

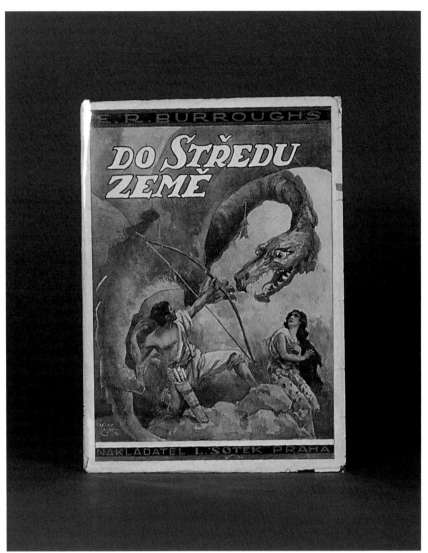

At the Earth's Core, Czech paperback, Sotek, 1927 (cover by Vaclav Cutta - note similarity to St. John). $100-$120

At the Earth's Core, British paperback, Tandem, 1975 (no art credit). $6-$8

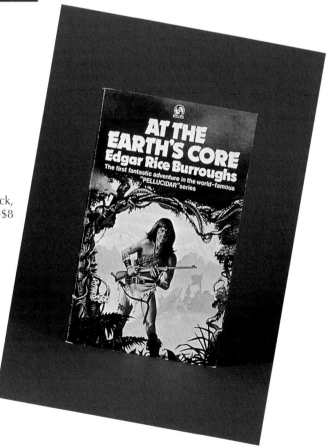

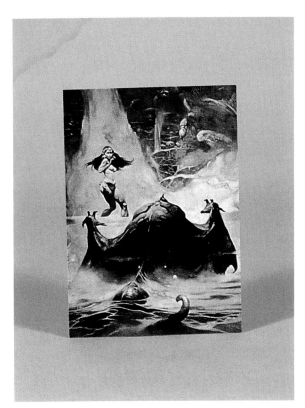

At the Earth's Core, trading card, Comic Images, 1991 (art by Frank Frazetta). 15 cents

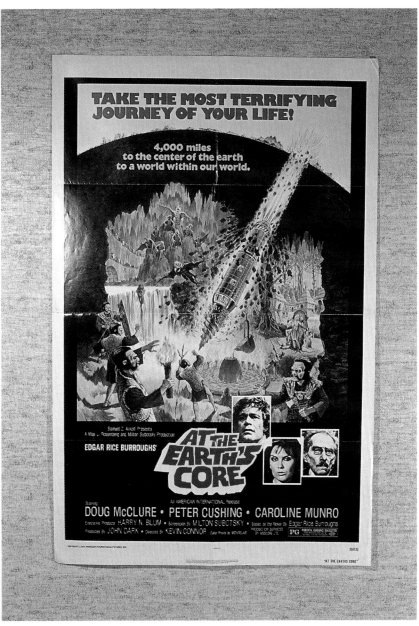

At the Earth's Core, movie poster (one sheet, 27 x 41), AIP, 1975. $20-$30

Pellucidar

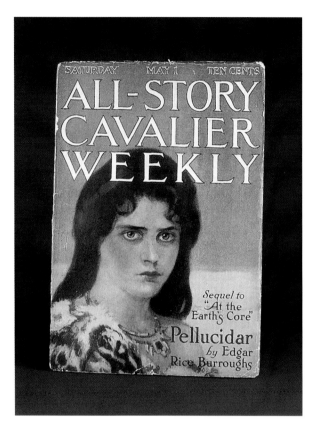

Pellucidar, pulp magazine, *All-Story Weekly*, May 1, 1915 (cover by Modest Stein). $175-$220

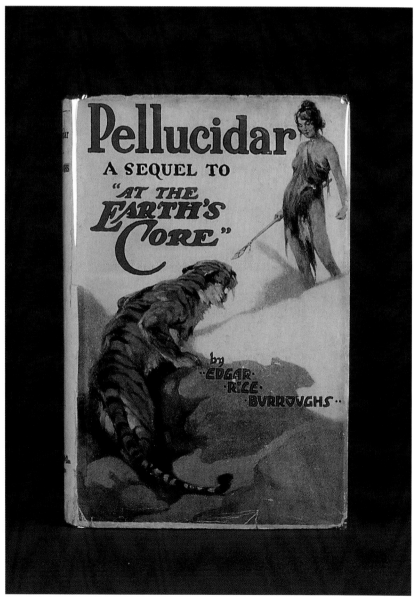

Pellucidar, hardcover, McClurg, September 5, 1923 (cover by J. Allen St. John). $900-$1,600

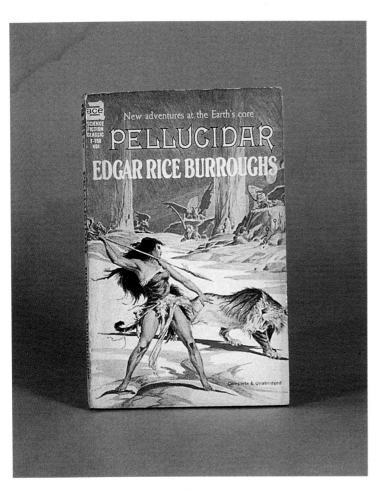

Pellucidar, paperback, Ace #F-158,
undated (cover by Roy Krenkel).
$7-$9

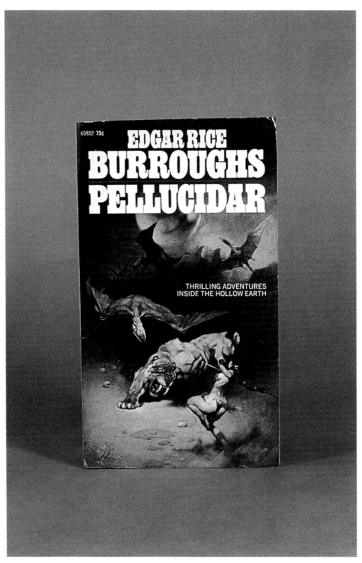

Pellucidar, paperback, Ace
#65852, 1975 (cover by
Frank Frazetta). $5-$7

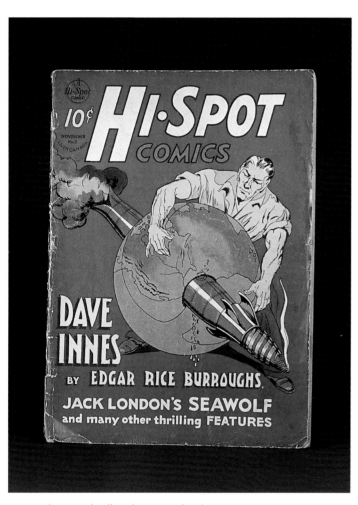

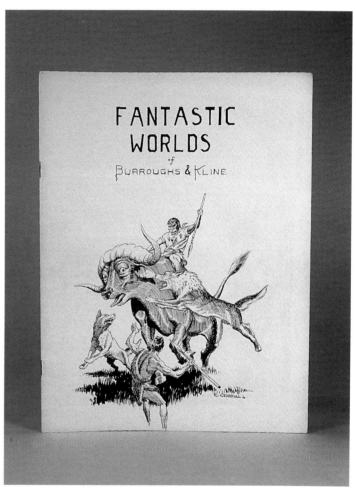

David Innes of Pellucidar, comic book, Hi Spot Comics #2, November 1940 (art by John Coleman Burroughs). $300-$500

Fantastic World of Burroughs & Kline #1, fanzine, published by Philip Currie, September 1965 (cover by Reed Crandall). $10-$15

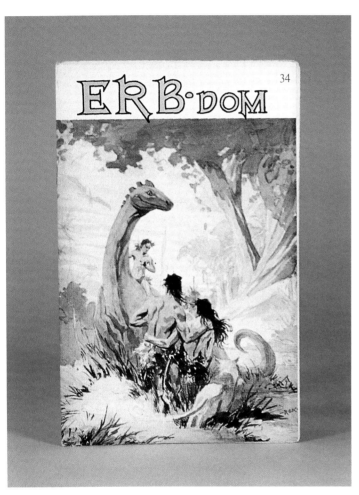

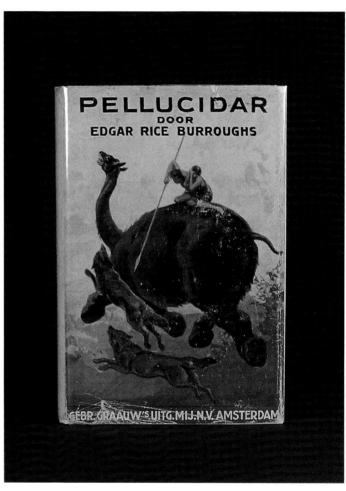

ERB-dom #34, fanzine, published by Camille Cazedessus, Jr., May 1970 (cover by Roy Krenkel). $10-$15

Pellucidar, Dutch hardcover, Graauw, 1950 (no art credit). $30-$50

Pellucidar, Japanese paperback,
Hayakawa, 1965 (cover by Roy
Krenkel). $9-$12

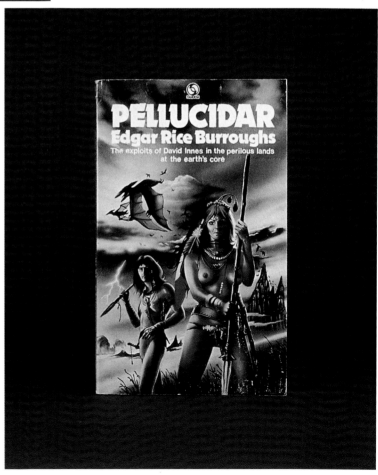

Pellucidar, British paperback,
Tandem, 1975 (no art credit).
$7-$9

26

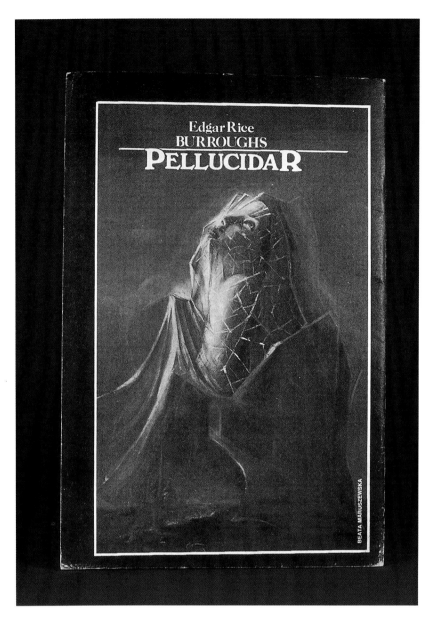

Pellucidar, Polish paperback, Fantastyka, 1985 (cover by Beata Maruszewska). $7-$9

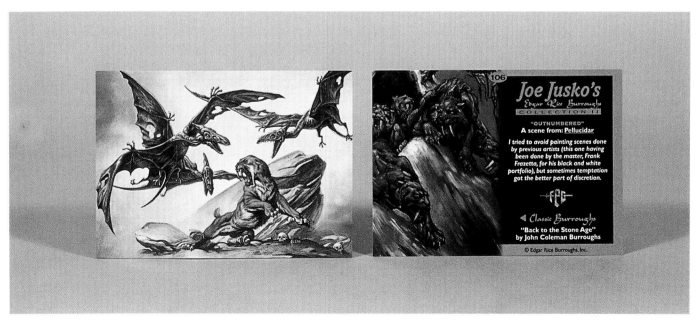

Outnumbered - Back to the Stone Age, trading card (both sides), FPG, 1996 (art by Joe Jusko & John Coleman Burroughs). 25 cents

Tanar of Pellucidar

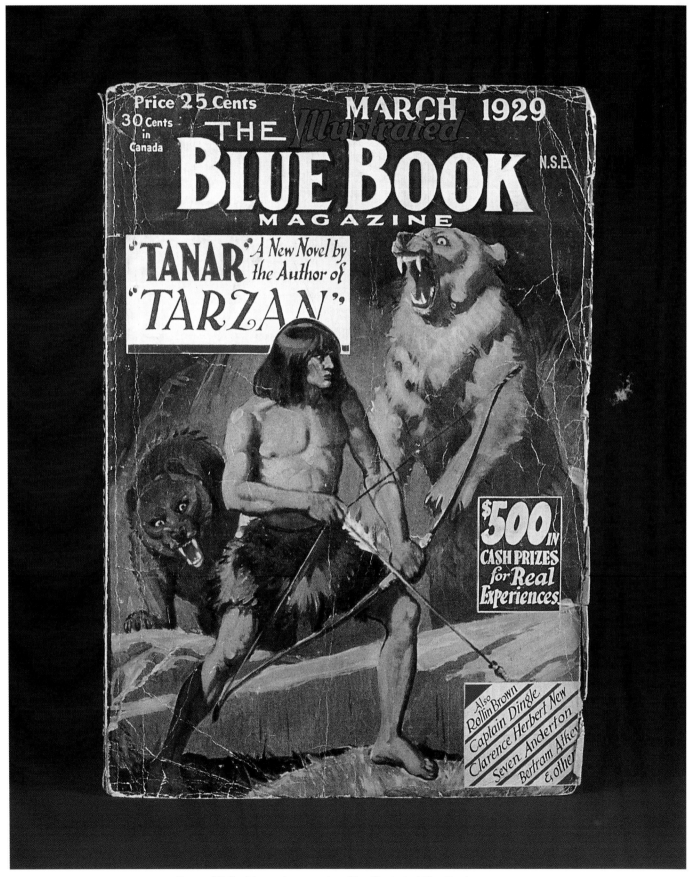

Tanar of Pellucidar, pulp magazine, *The Illustrated Blue Book
Magazine*, March 1929 (cover by Frank Hoban). $55-$65

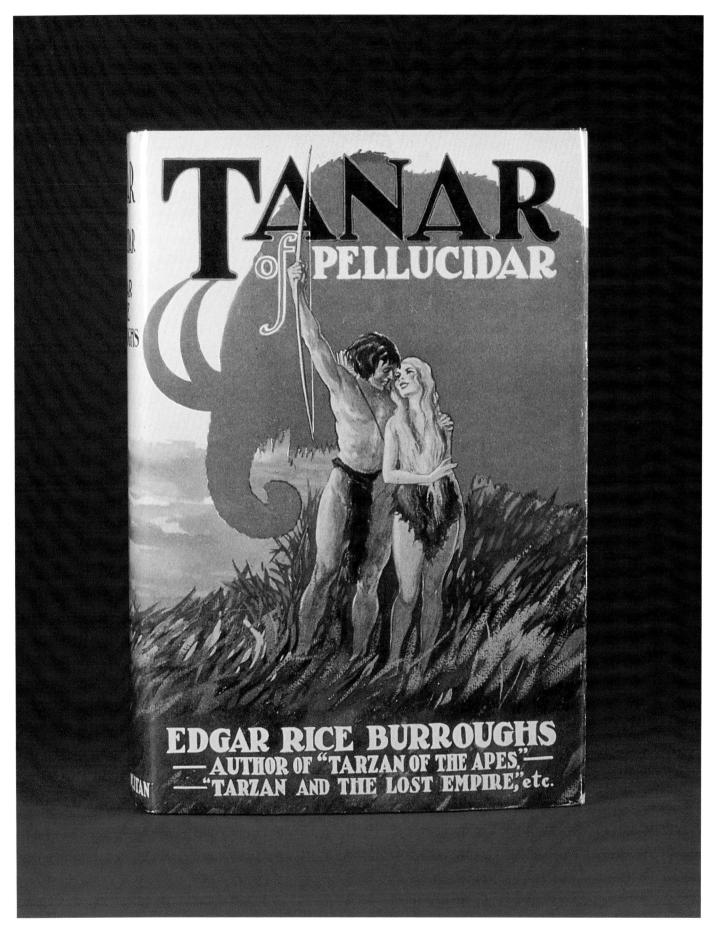

Tanar of Pellucidar, hardcover, Metropolitan, May 29,
1930 (cover by Paul F. Berdanier). $1,300-$2,000

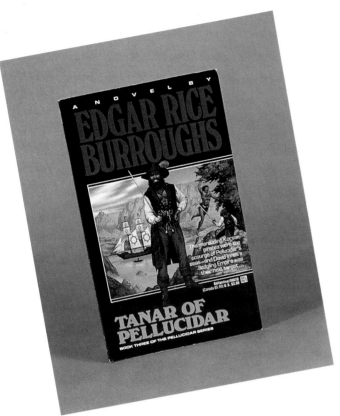

Tanar of Pellucidar, paperback, Ballantine #36670, 1990 (cover by David Mattingly). $4-$6

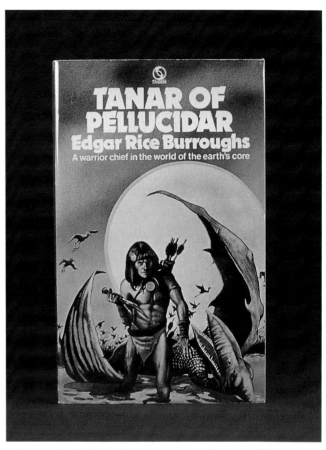

Tanar of Pellucidar, British paperback, Tandem, 1974 (no art credit). $5-$7

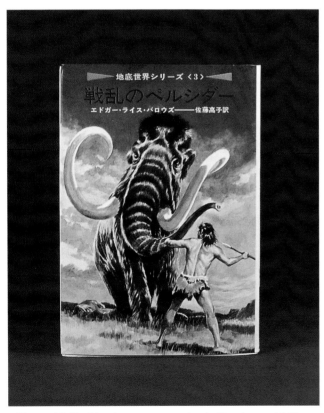

Tanar of Pellucidar, Japanese paperback, Hayakawa, 1963 (cover by Roy Krenkel). $9-$12

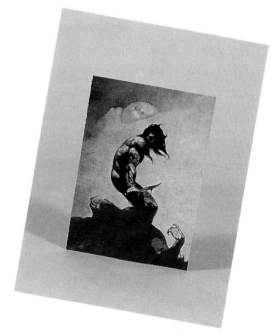

Tanar of Pellucidar, trading card, Comic Images, 1991 (art by Frank Frazetta). 15 cents

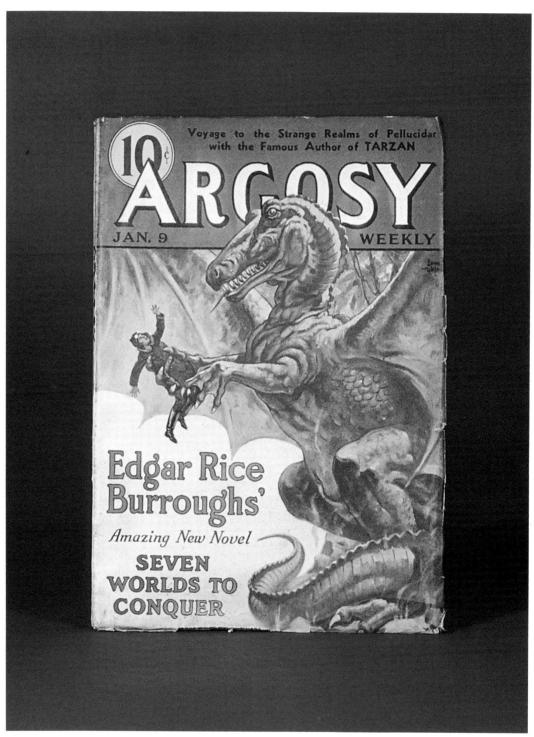

Seven Worlds to Conquer (Back to the Stone Age), pulp magazine, *Argosy Weekly*, January 9, 1937 (cover by Emmett Watson). $40-$50

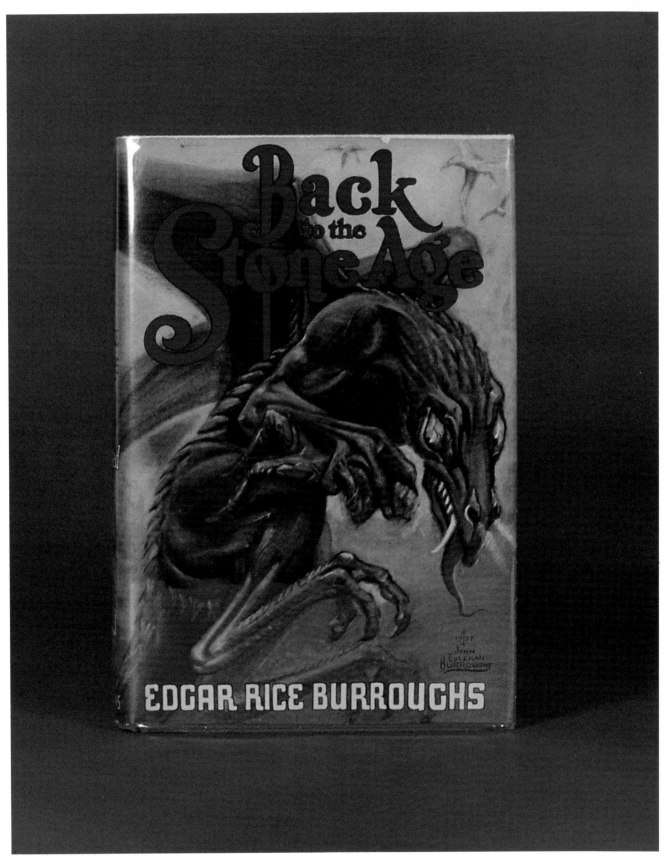

Back to the Stone Age, hardcover, Burroughs,
September 15, 1937 (cover by John Coleman
Burroughs). $1,100-$1,800

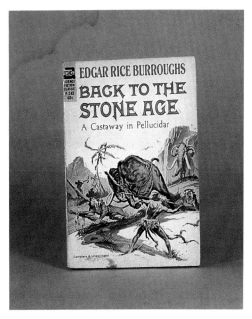

Back to the Stone Age, paperback, Ace #245, undated (cover by Roy Krenkel). $6-$8

Back to the Stone Age, British paperback, Tandem, 1973 (no art credit). $5-$7

Back to the Stone Age, trading card, FPG, 1995 (art by David Mattingly). 15 cents

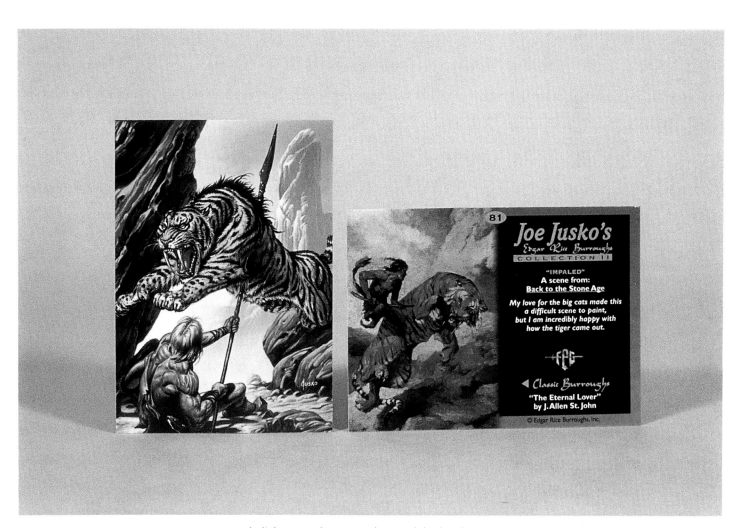

Impaled/The Eternal Lover, trading card (both sides), FPG, 1995 (art by Joe Jusko & J. Allen St. John). 25 cents

Land of Terror, hardcover (no pulp appearance), Burroughs, May
1, 1944 (cover by John Coleman Burroughs). $600-$800

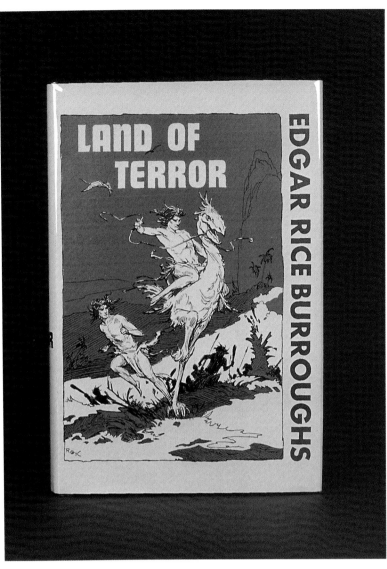

Land of Terror, hardcover, Canaveral, November 15, 1963 (cover by Roy Krenkel). $50-$75

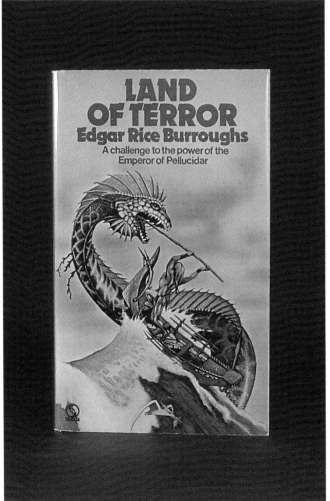

Land of Terror, British paperback, Tandem, 1974 (no art credit). $4-$6

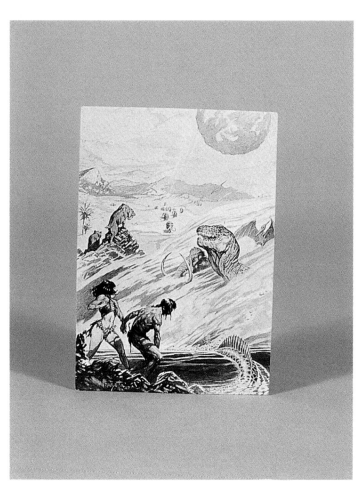

Land of Terror, trading card, Comic Images, 1993 (art by Frank Frazetta). 15 cents

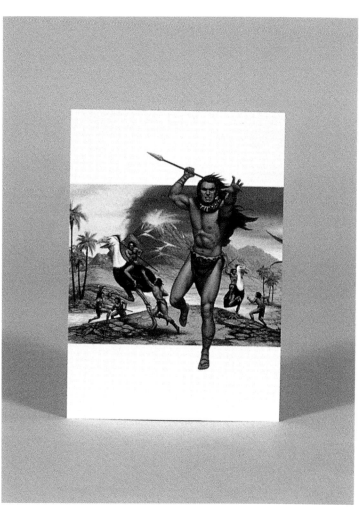

Land of Terror, trading card, FPG, 1995 (art by David Mattingly). 15 cents

Savage Pellucidar

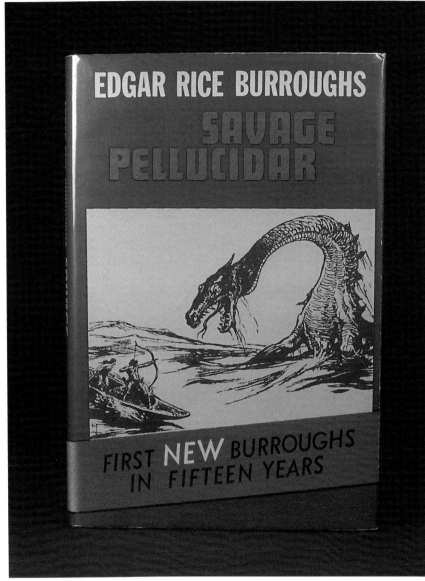

Savage Pellucidar, hardcover (appeared in pulp, Amazing Stories, February 1942, no cover), Canaveral, November 25, 1963 (cover by J. Allen St. John). $50-$90

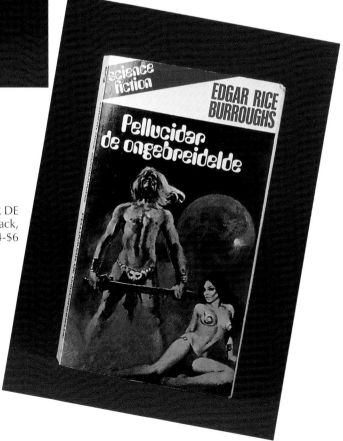

Savage Pellucidar (PELLUCIDAR DE ONGEBREIDELDE), Dutch paperback, KC, 1973 (cover by Jeffrey Jones). $4-$6

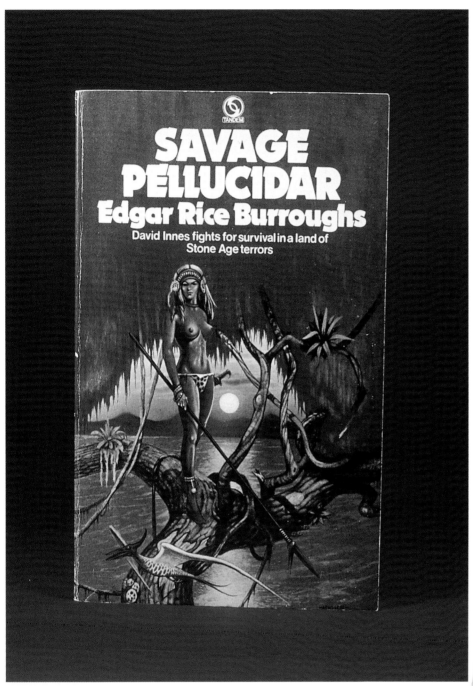

Savage Pellucidar, trading card,
Comic Images, 1991 (art by Frank
Frazetta). 15 cents

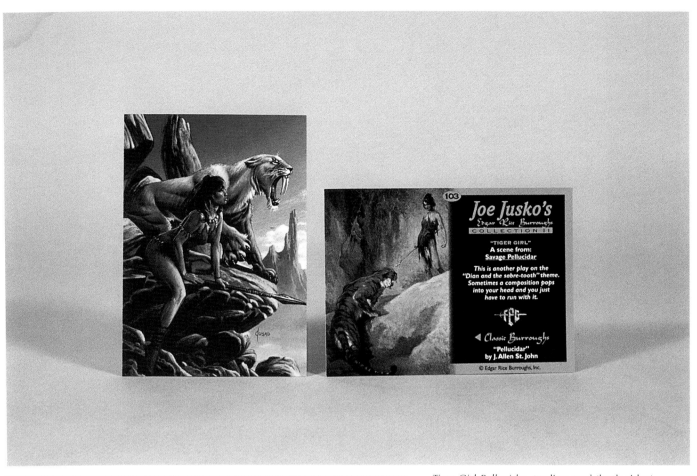

Tiger Girl-Pellucidar, trading card (both sides), FPG, 1995 (art by Joe Jusko & J. Allen St. John). 25 cents

Savage Pellucidar, trading card, FPG, 1995 (art by David Mattingly). 15 cents

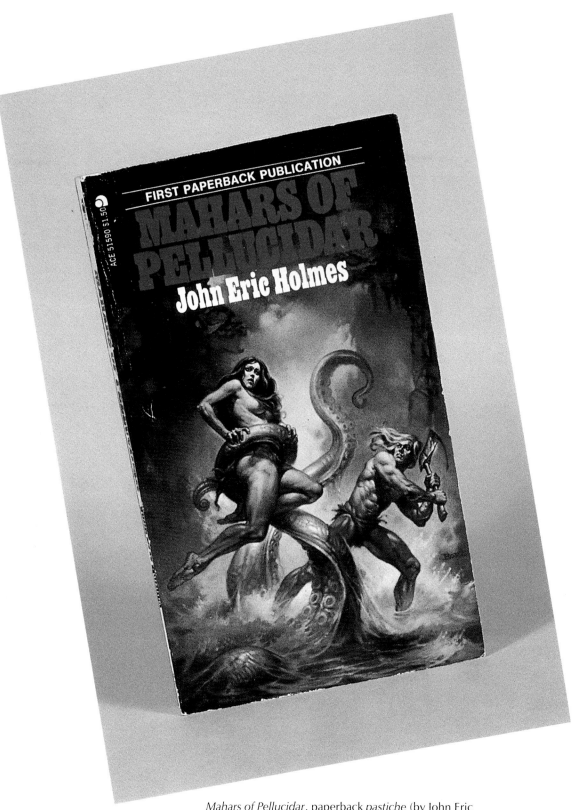

Mahars of Pellucidar, paperback *pastiche* (by John Eric
Holmes), Ace #51590, 1976 (cover by Boris Vallejo).
$6-$8

Historical

The Outlaw of Torn

The Outlaw of Torn, though Burroughs' second published tale, would not make it into book form for a long time after its first appearance in *All-Story Magazine*. Not as well received as his other stories, ERB's history-based tales still allowed him to create fast-paced and absorbing story-lines—from ancient Rome to a *Graustarkian* principality. More conventional than his science fiction novels, the historical romances still have the ability to sweep the reader up in electric adventure, taking him on a voyage in time, rather than space.

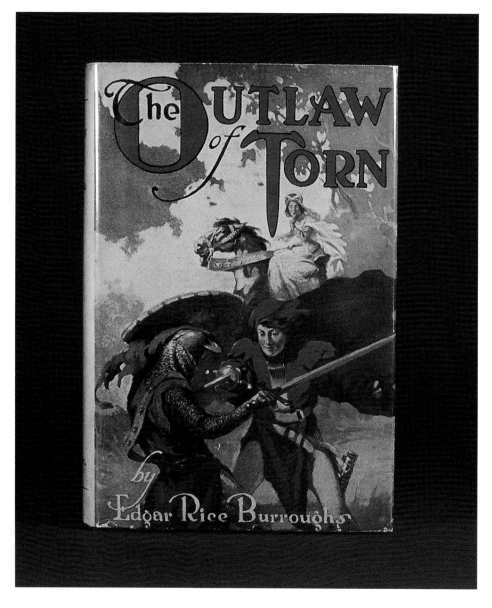

The Outlaw of Torn, hardcover (appeared in pulp magazine, *News Story Magazine*, January 1914, no cover), McClurg, February 19, 1927 (cover by J. Allen St. John). $1,200-$1,800

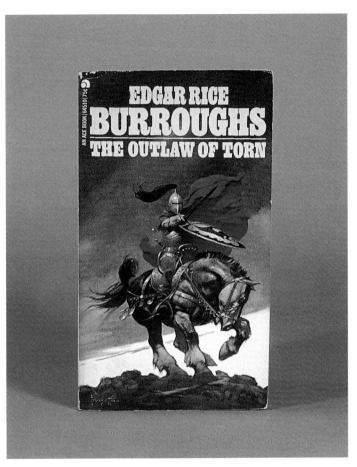

The Outlaw of Torn, paperback, Ace #64510, undated (cover by Frank Frazetta). $4-$6

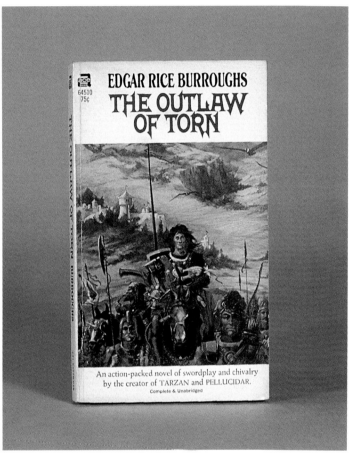

The Outlaw of Torn, paperback, Ace #64510, undated (cover by Roy Krenkel). $4-$6

The Outlaw of Torn, promotional flyer, McClurg, 1927. $60-$75

Everybody's Reading
The Outlaw of Torn
Because It's Written for Everybody!

For "You"
You, like everyone else, enjoy reading a good, well written, thrilling story. THE OUTLAW OF TORN is more than you've ever expected of any story. It is really a daring tale that Edgar Rice Burroughs has reconstructed from forgotten pages of history. Its reality makes you live the story.

For "Her"
Mother, sister, sweetheart, they'll love THE OUTLAW OF TORN, who followed a career more romantic than the far-famed Robin Hood. They'll be captivated by the romance and adventures of this high-born outlaw, who had been schooled in ferocity and cruelty that only a great love could subdue. Get "her" a copy.

For The "Busy Business Man"
Work! Work! Work! Just the thing to relax his tired mind and enable him to gather together the frayed nerve ends so that he can attack new problems with renewed energy. His interest will be aroused by this tale of a lost prince, son of Henry III of England, who is ignorant of his royal blood. Get him THE OUTLAW OF TORN.

For "Him"
Maybe it's Bill's birthday or Dad's going on a trip, or Uncle Henry is convalescing, or Grandfather just reads to pass the time away. What could be better than a copy of THE OUTLAW OF TORN? It's a book they'll all be interested in, whether they're sixteen or sixty. Don't delay, buy one today.

For The "Mrs."
You husbands that don't know why your wife is "crabby" once in a while when you come home, get a copy of THE OUTLAW OF TORN for her and see the change! Housework or the children can easily tire her, but if she has a story like this to read she'll forget that tired feeling. Try it!

For "Hubby"
When "hubby" gets home at night after a fatiguing day at the office there's no one that will appreciate a good pipe or cigar, the radio and a copy of THE OUTLAW OF TORN more than he. It's a story that is a sure cure for that "tired feeling." It beats reading about the latest scandal or a gruesome murder. Get him a copy, you can't go wrong.

The Outlaw of Torn, British paperback, Pinnacle, September 1953 (cover by J.E. McConnell). $20-$30

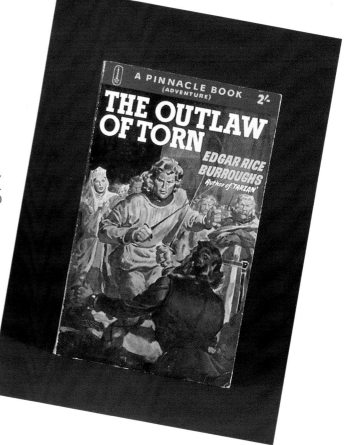

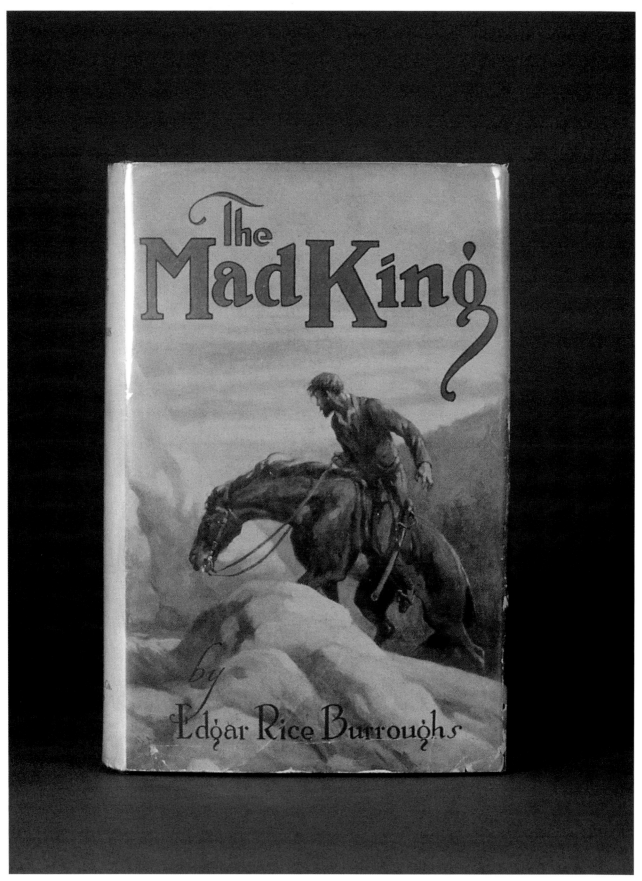

The Mad King, hardcover (appeared in pulp magazine, *All-Story Weekly*, March 21, 1914,
no cover), McClurg, September 18, 1926 (cover by J. Allen St. John). $1,200-$1,800

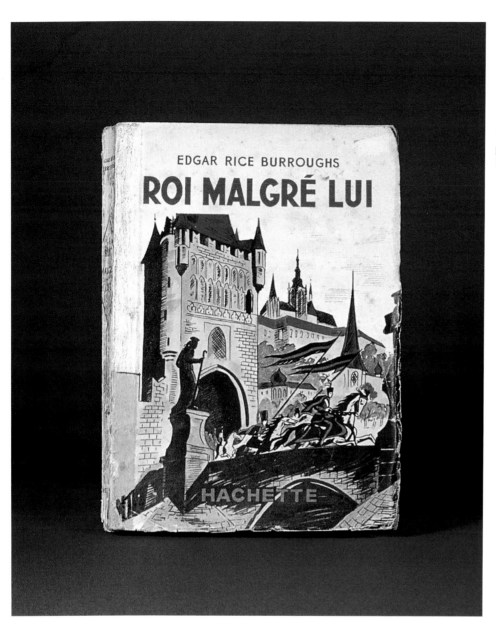

The Mad King (ROI MALGRE LUI), French paperback, Hatchette, 1937 (cover by Fibra). $175-$225

The Mad King, trading card, Comic Images, 1991 (art by Frank Frazetta). 15 cents

The Oakdale Affair

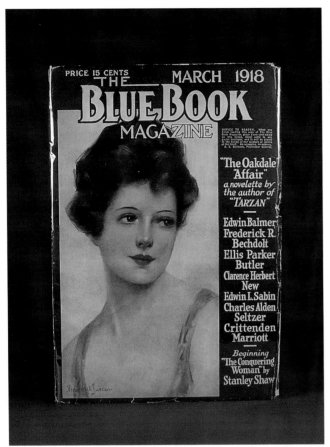

The Oakdale Affair, pulp magazine, *The Blue Book Magazine*, March 1918 (cover by Don J. Lavin). $65-$85

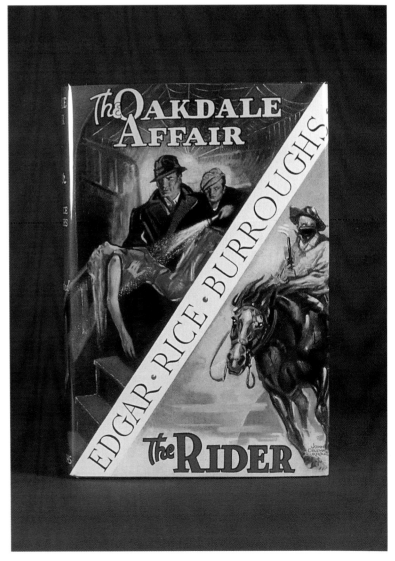

The Oakdale Affair/The Rider, hardcover, Burroughs, February 15, 1937 (cover by John Coleman Burroughs). $500-$800

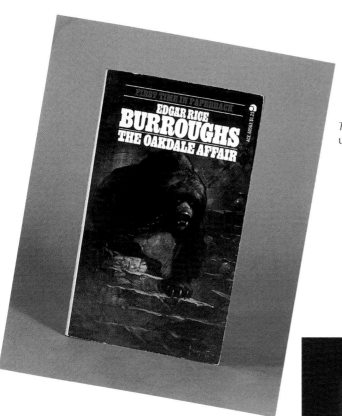

The Oakdale Affair, paperback, Ace #60563, undated (cover by Frank Frazetta). $10-$15

The Oakdale Affair, British movie program, 1917. $125-$150

Mercury
FILM SERVICE

Film House, Mill Hill, Leeds

offer you

Seven House-Filling

Propositions

	FEATURING
The Scar . . .	Kitty Gordon
The Oakdale Affair	Evelyn Greeley
Three Green Eyes	Carlyle Blackwell / Montague Love / Evelyn Greeley / June Elvidge
The Purple Lily	Kitty Gordon
His Father's Wife	June Elvidge
The Heart of a Hero	Robert Warwick / Gail Kane
The Red Woman	June Elvidge / Gail Kane

OWNED and CONTROLLED for
YORKSHIRE, LINCOLNSHIRE AND
FOUR NORTHERN COUNTIES

Telegrams : "Merfilm" Phone **26946**

The Rider

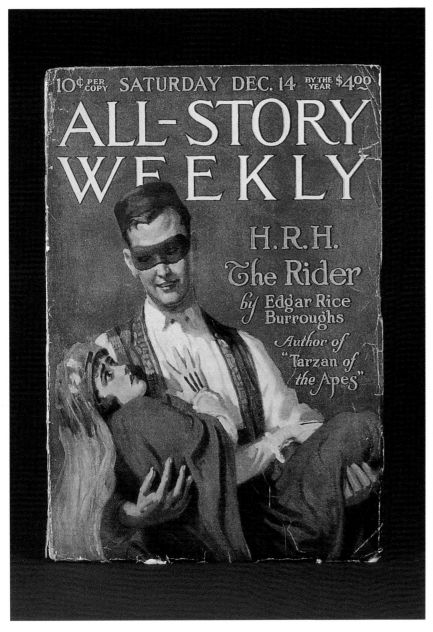

H.R.H. The Rider, pulp magazine, *All-Story Weekly*, December 14, 1918 (cover by George Brehm). $175-$200

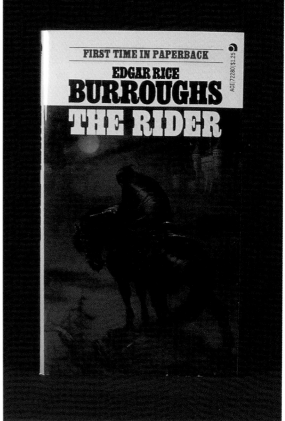

The Rider, paperback, Ace #72280, October 1974 (cover by Frank Frazetta). $4-$6

I am a Barbarian

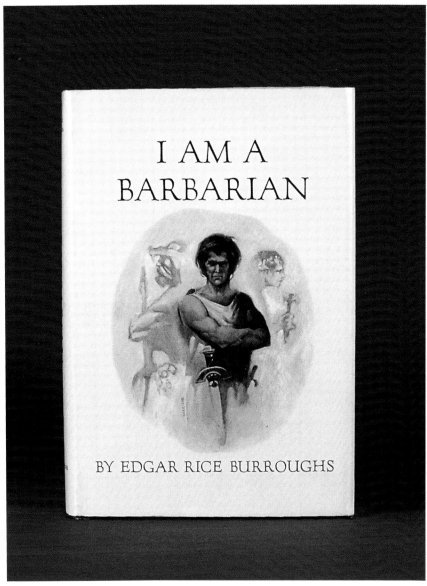

I Am A Barbarian, hardcover (no pulp appearance), Burroughs, September 1, 1967 (cover by Jeffrey Jones). $80-$110

I Am A Barbarian, trading card, Comic Images, 1991 (art by Boris Vallejo). 15 cents

Moon & Stars

The Moon Maid (including *The Moon Men*)
Tales of Three Planets (comprised of *Beyond the Farthest Star, Resurrection of Jimber-Jaw,*
and *The Wizard of Venus*)

That ERB was fascinated with life on other planets is evidenced by these and other tales. While not as evolved, and separate from the other *off-world* novels, *The Moon Maid*, and *Tales of Three Planets* are showcases for Burroughs' fertile imaginings.

The Moon Maid

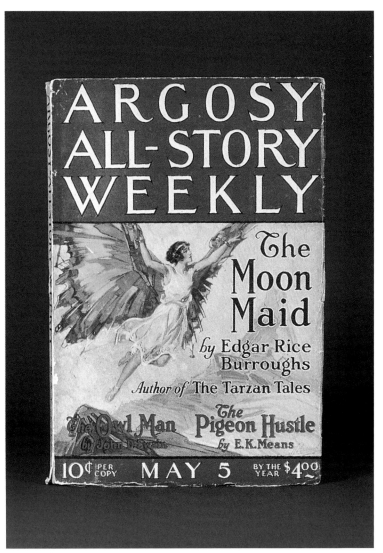

The Moon Maid, pulp magazine, *Argosy All-Story Weekly*, May 5, 1923 (cover by P. J. Monahan). $150-$175

Opposite page:
The Moon Maid, hardcover, McClurg, February 6, 1926 (cover by J. Allen St. John). $1,800-$2,700

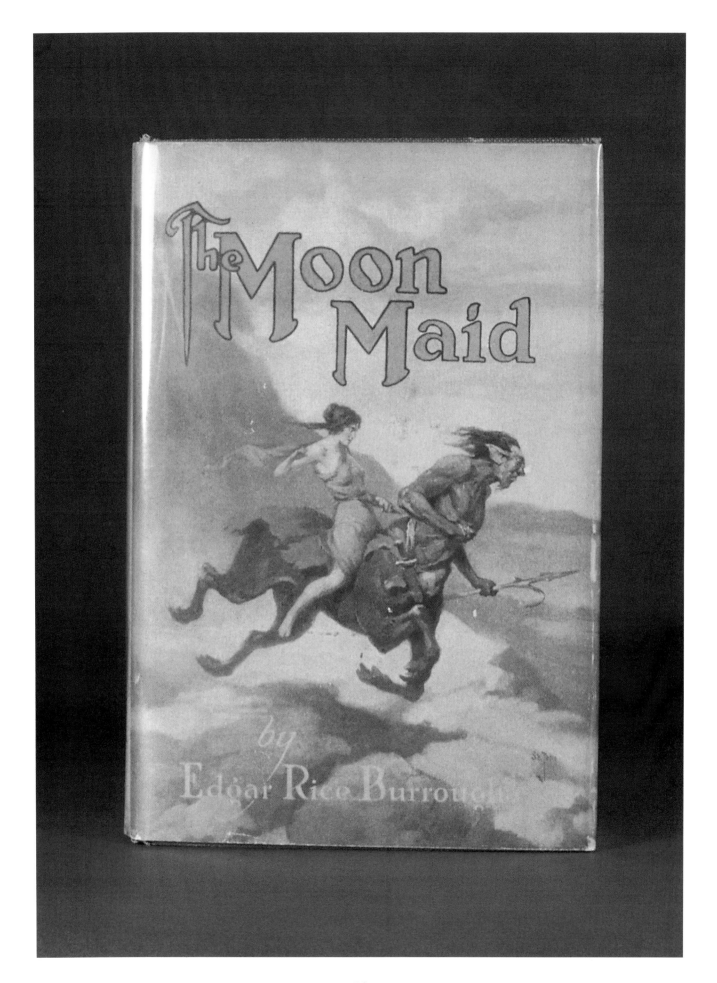

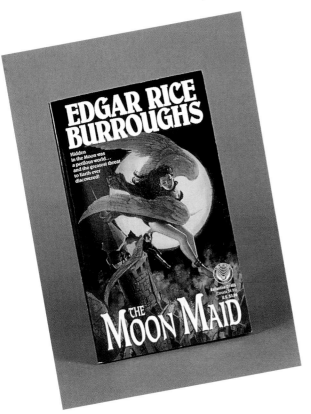

The Moon Maid, paperback,
Ballantine #37405, 1992 (cover by
Lawrence Schwinger). $4-$6

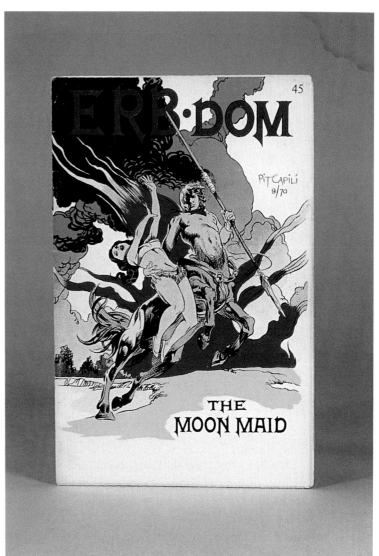

ERB-dom #45, fanzine, published by Camille Cazedessus, Jr.,
April 1971 (cover by Pit Capili). $10-$12

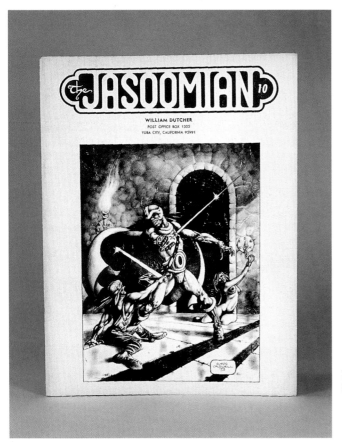

The Jasoomian $10, fanzine, published by William
Dutcher, June 1973 (cover by Clyde Caldwell). $10-$12

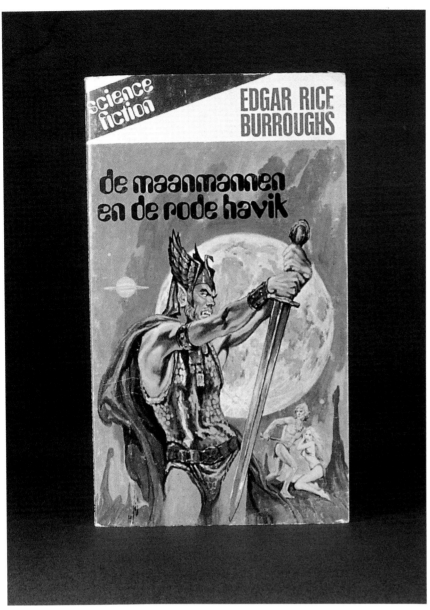

The Moon Men/The Red Hawk (DE MAANMANNEN EN DE RODE HAVIK), Dutch paperback, Ridderhof, undated (no art credit). $9-$11

The Moon Maid, trading card, Comic Images, 1991, (art by Frank Frazetta). 15 cents

Tales of Three Planets

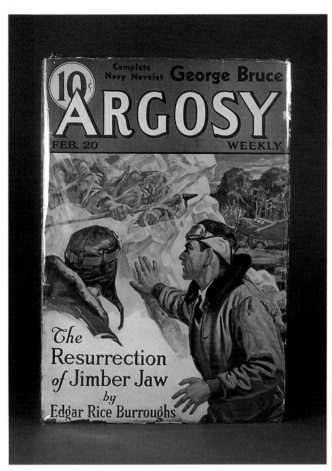

The Resurrection of Jimber Jaw, pulp magazine,
Argosy Weekly, February 20, 1937 (cover by
Emmett Watson). $45-$55

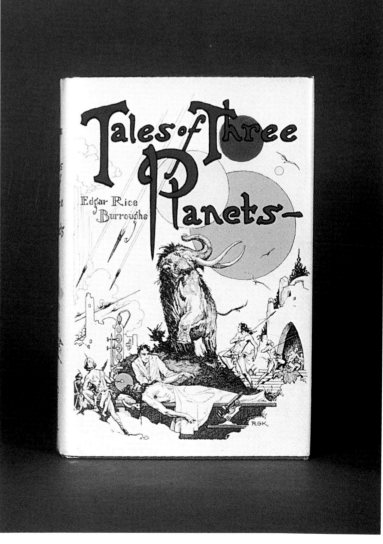

Tales of Three Planets, hardcover,
Canaveral, April 27, 1964 (cover by Roy
Krenkel). $50-$75

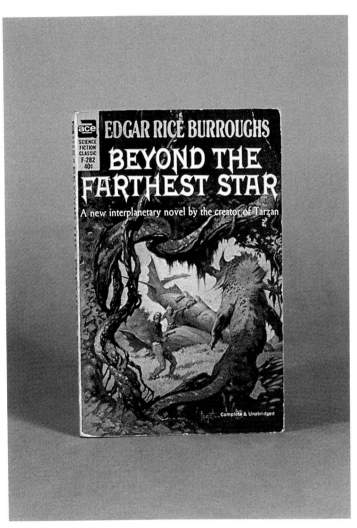

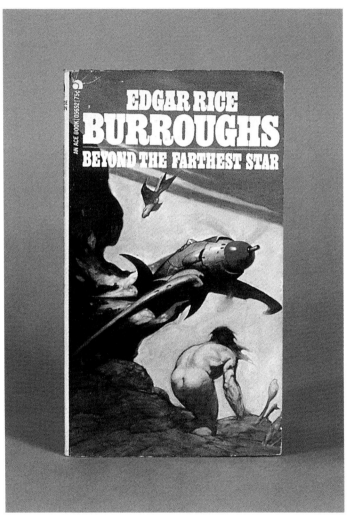

Beyond the Farthest Star, paperback (appeared in pulp magazine, *The Blue Book Magazine*, January 1942, no cover), Ace #F-282, 1964 (cover by Frank Frazetta). $6-$9

Beyond the Farthest Star, paperback, Ace #05652, 1973 (cover by Frank Frazetta). $4-$6

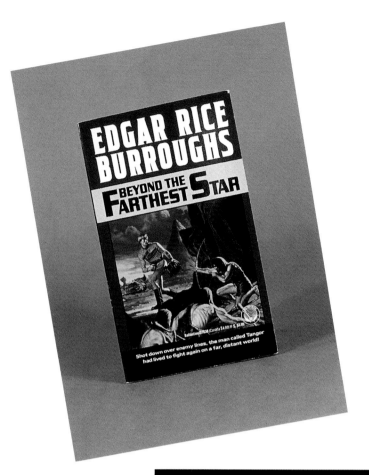

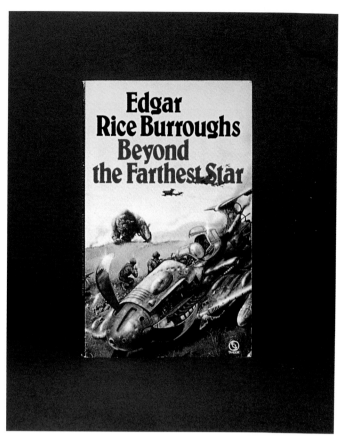

Beyond the Farthest Star, paperback, Ballantine #37836, 1992 (cover by Michael Herring). $4-$6

Beyond the Farthest Star, British paperback, Tandem, 1964 (no art credit). $5-$7

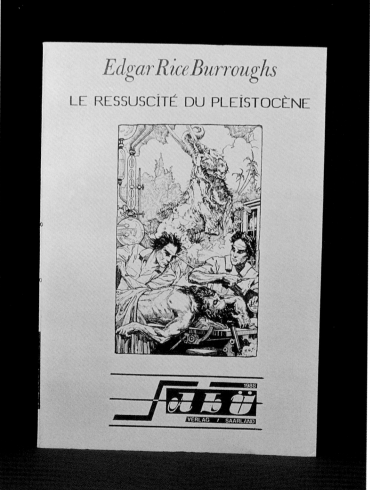

Beyond the Farthest Star (LE RESSUCITE DU PLEISTOCENE), French paperback, ALU, 1988 (cover by Roy Krenkel). $5-$7

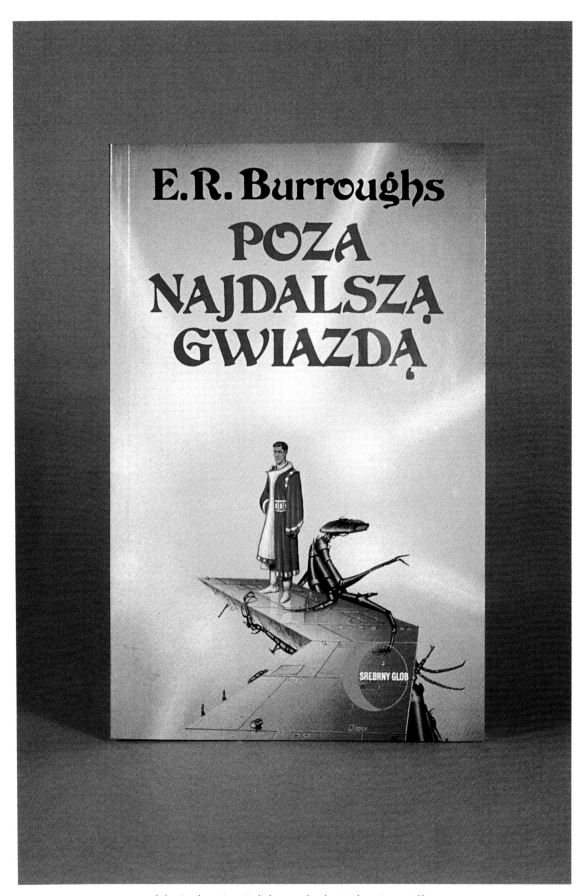

Beyond the Farthest Star, Polish paperback, Wydawnictwo Alfa, 1994
(cover by Michelangelo Miani). $5-$7

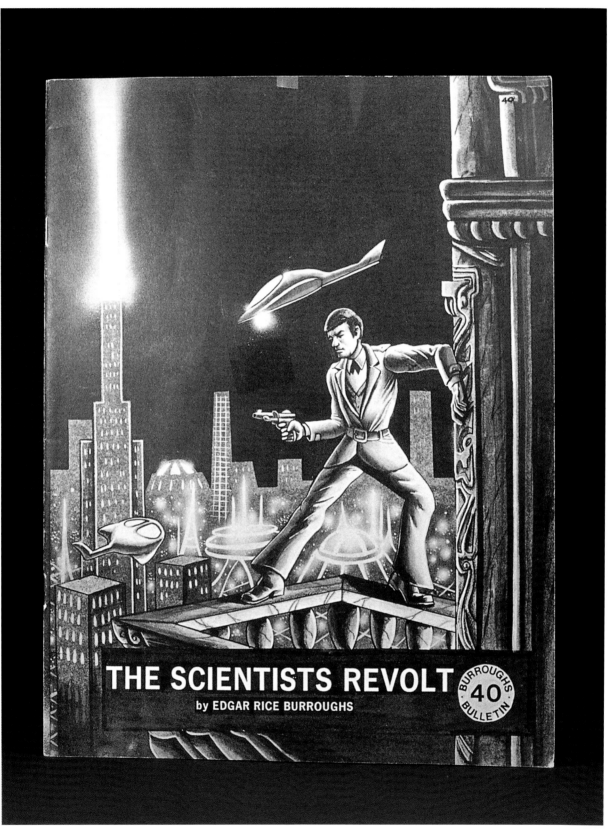

The Scientist's Revolt, fanzine (appeared in pulp magazine, *Fantastic Adventures*, July 1939, no cover), Burroughs Bibliophile #40, August 1974 (cover by Herb Arnold). $10-$12

Chapter Five
Westerns

The War Chief
Apache Devil
The Bandit of Hell's Bend
The Deputy Sheriff of Comanche County

Incorporating ERB's own experiences as a cowboy, prospector, and cavalryman, these well-researched tales reflect a very personal attitude towards a conception of the "Western Code" that appears in many of his works. The quiet, indomitable hero is a theme that ERB applied to many of his heroes; these include his first, John Carter.

The long, hot days spent under the scorching Arizona sun during his brief stint with the 7th Cavalry at Fort Grant probably helped form Burroughs' compassionate viewpoint of Native Americans (as compared to many of his contemporaries, who often cast Indians as villains, or worse). This is deserving of note, especially when current critics are so prone to gauge the politics of a long-dead writer by today's social standards.

Though one of the smallest body of groupings, ERB's Westerns are still being reprinted, particularly abroad, where this genre still has a strong hold on readers.

The War Chief

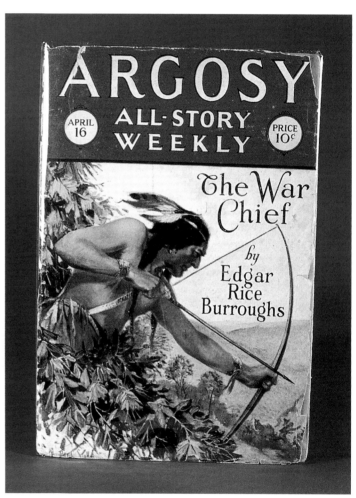

The War Chief, pulp magazine, *Argosy All-Story Weekly*, April 16, 1927 (cover by Paul Stahr, repeated on hardcover - not shown). $100-$125

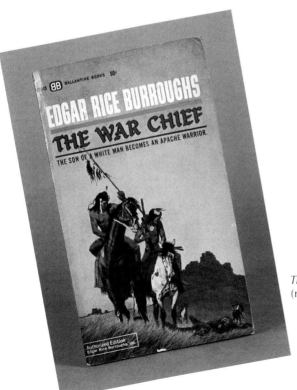

The War Chief, paperback, Ballantine #U-2045, 1964 (no art credit). $8-$10

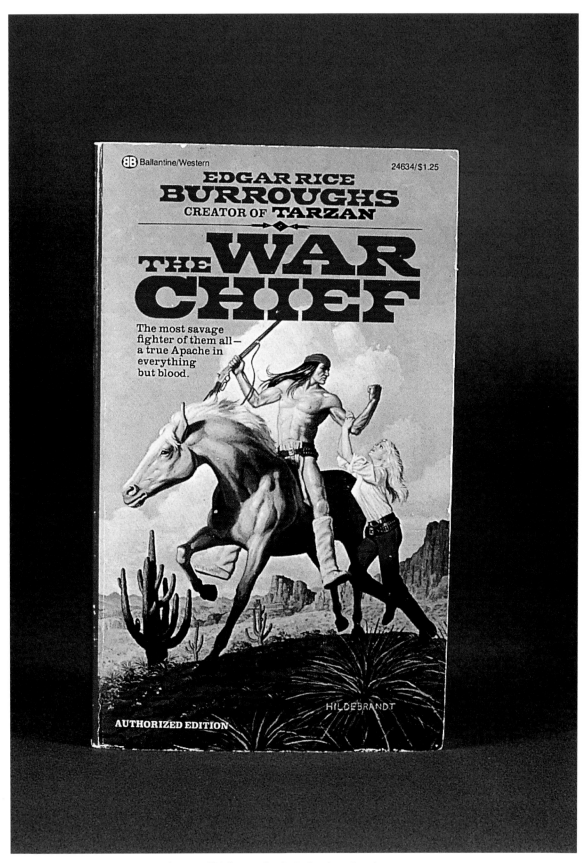

The War Chief, paperback, Ballantine, October 1975
(cover by the Brothers Hildebrandt). $6-$8

Apache Devil

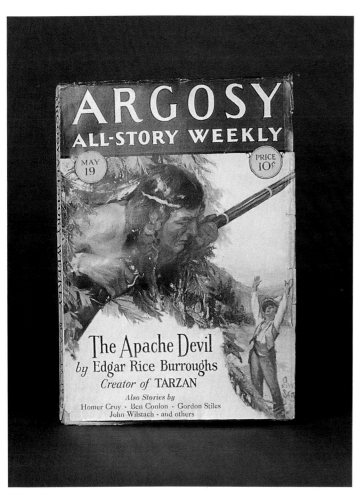

Apache Devil, pulp magazine, *Argosy All-Story Weekly*, May 19, 1928 (cover by Paul Stahr). $50-$60

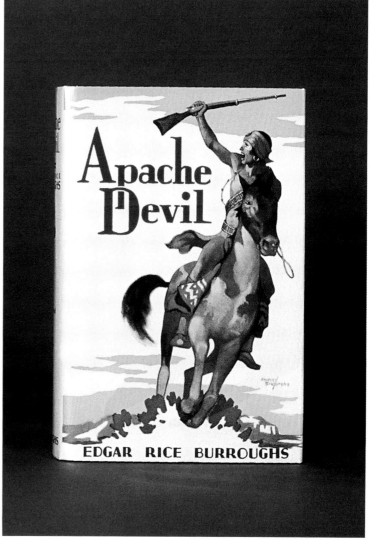

Apache Devil, hardcover, Burroughs, February 15, 1933 (cover by Studley O. Burroughs). $300-$500

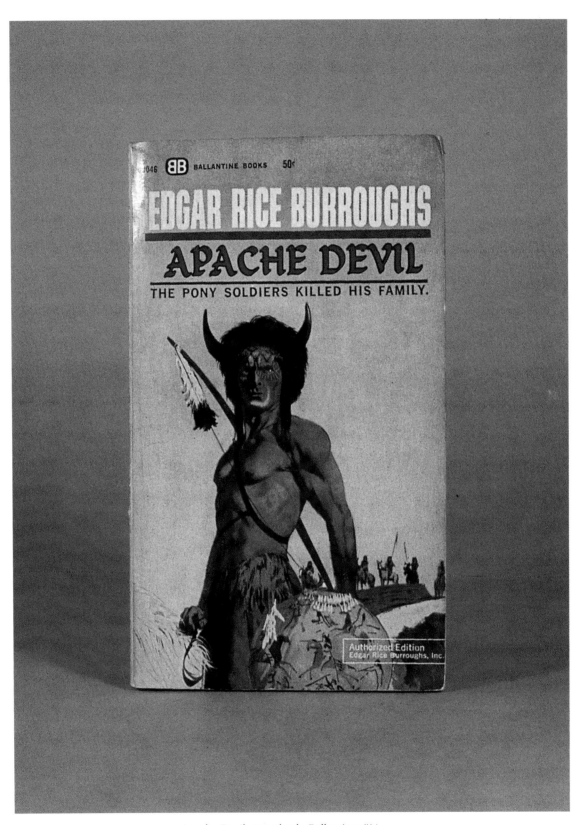

Apache Devil, paperback, Ballantine #U-
2046, 1964 (no art credit). $8-$10

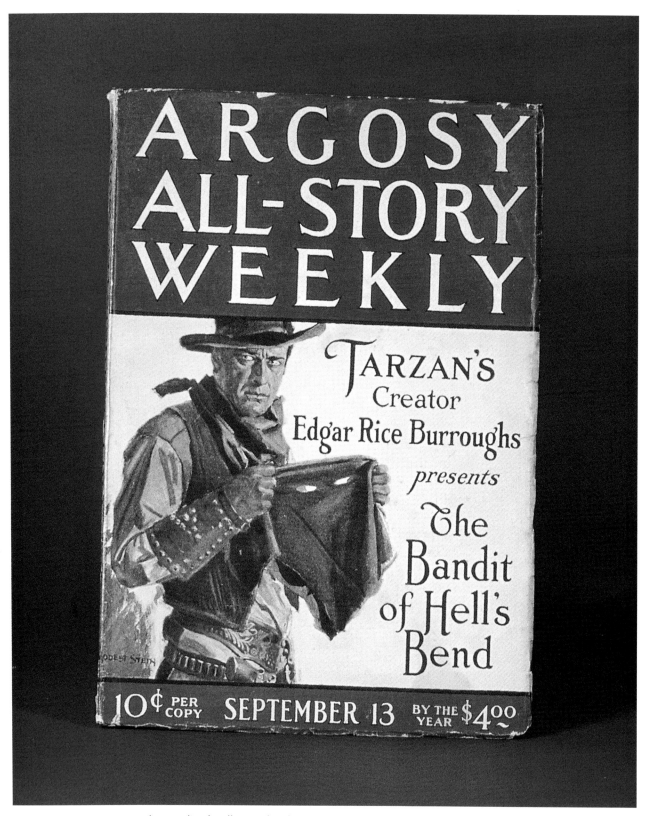

The Bandit of Hell's Bend, pulp magazine, *Argosy All-Story Weekly*,
September 13, 1924 (cover by Modest Stein). $100-$125

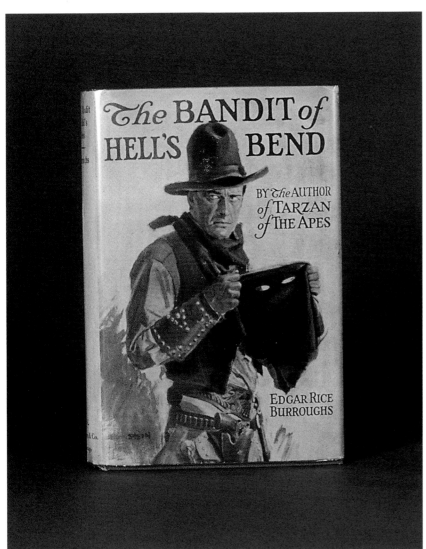

The Bandit of Hell's Bend, hardcover, McClurg, June 4, 1925 (cover by Modest Stein - same as pulp). $1,200-$1,800

The Bandit of Hell's Bend, paperback, Ace #04745, undated (cover by Boris Vallejo). $7-$9

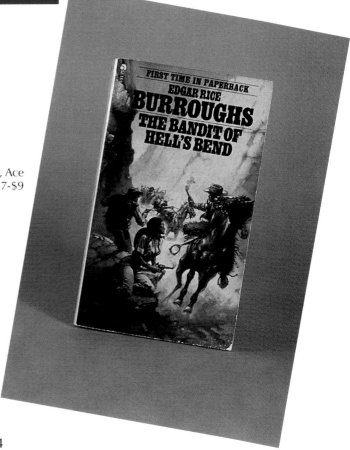

64

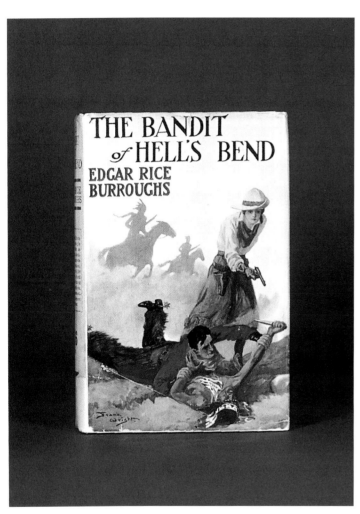

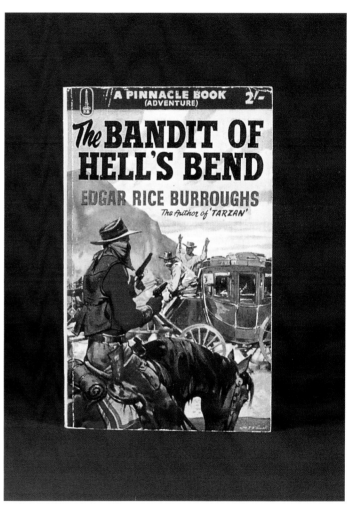

The Bandit of Hell's Bend, British hardcover, Methuen, March 1929 (Cover by Frank Wright). $180-$225

The Bandit of Hell's Bend, British paperback, Pinnacle, December 1953 (cover by J. E. McConnell). $12-$16

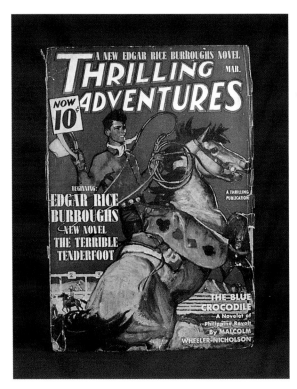

The Terrible Tenderfoot (*The Deputy Sheriff of Comanche County*), pulp magazine, *Thrilling Adventures*, March 1940 (cover by C. A. Murphy). $40-$50

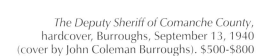

The Deputy Sheriff of Comanche County, hardcover, Burroughs, September 13, 1940 (cover by John Coleman Burroughs). $500-$800

The Deputy Sheriff of Comanche County, hardcover, Gregg, 1979
(cover by John Coleman Burroughs - from first edition). $65-$85

Chapter Six
Caspak

The Land that Time Forgot (including *The People that Time Forgot*, and *Out of Time's Abyss*)

This group of stories follows the adventures of Bowen Tyler, captive aboard a German U-boat during the First World War. He finds himself on the mysterious forgotten island continent of Caspak, at odds with dinosaurs and Neolithic warriors.

The Land that Time Forgot

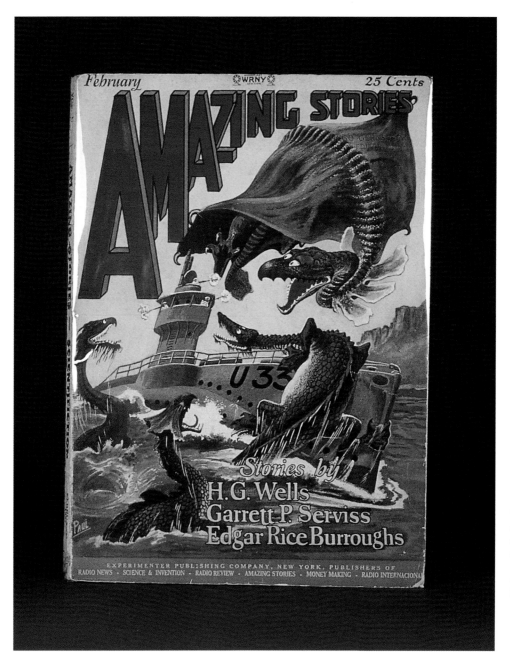

The Land That Time Forgot, pulp magazine (first pulp appearance was in *The Blue Book Magazine*, August 1918), *Amazing Stories*, February 1927 (cover by Frank R. Paul). $100-$120

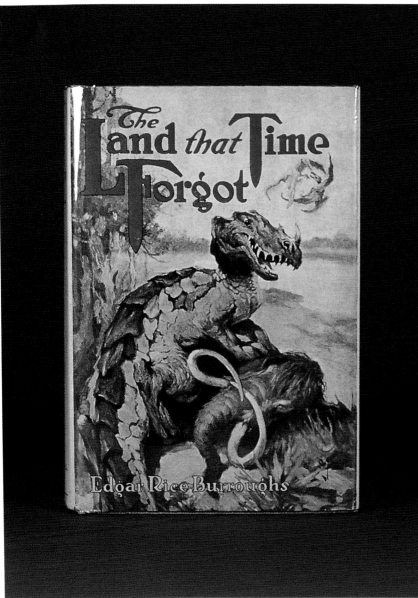

The Land That Time Forgot, hardcover, McClurg, June 14, 1924 (cover by J. Allen St. John). $3,000-$5,000

The Land That Time Forgot, trade paperback, University of Nebraska Press, 1999 (cover by R. W. Boeche). $14.95

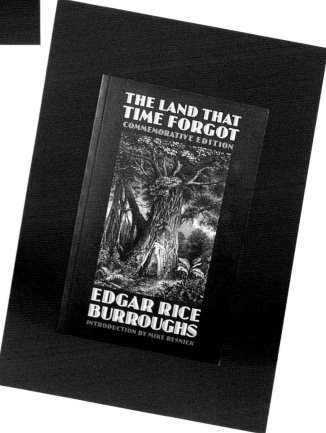

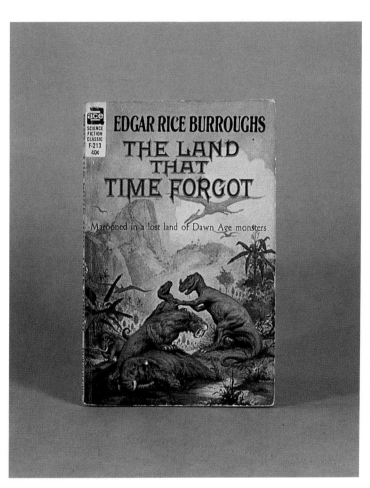

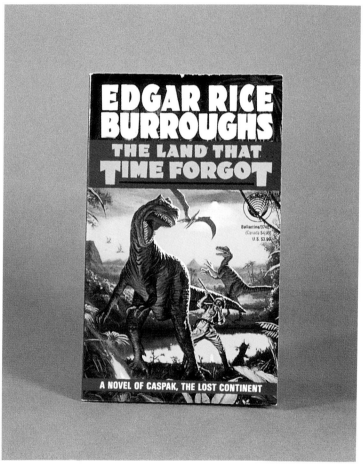

The Land That Time Forgot, paperback, Ace #F-213, undated
(cover by Roy Krenkel). $6-$8

The Land That Time Forgot, paperback, Ballantine #37407, 1992
(cover by Michael Herring). $4-$6

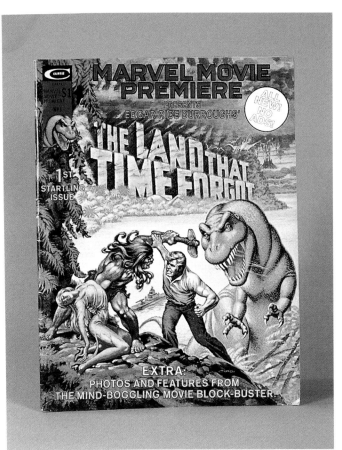

The Land That Time Forgot, comic book, *Marvel Movie Premier #1*, September 1975 (cover by Nick Cardy). $3-$5

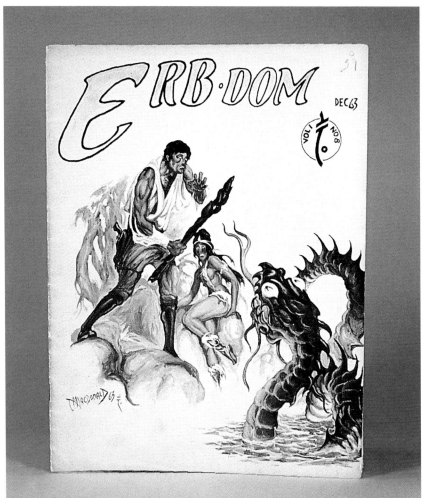

ERB-dom #8, fanzine, published by Camille Cazedessus, Jr., December 1963 (cover by Neal MacDonald). $10-$12

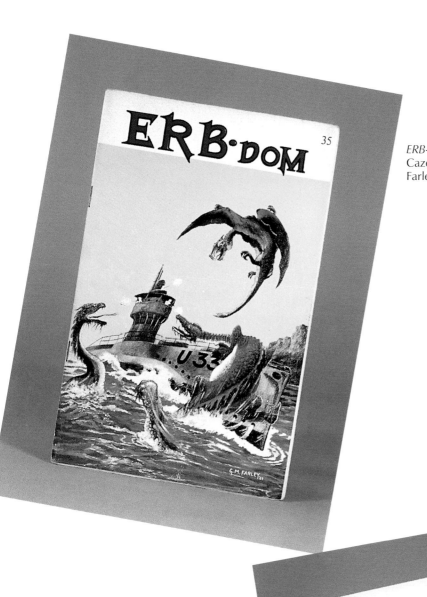

ERB-dom #35, fanzine, published by Camille Cazedessus, Jr., June 1970 (cover by G. M. Farley). $10-$12

Opposite page:
The Land That Time Forgot (TARIMUL UITAT DE TIMP), Romanian paperback, Albatross, 1973 (cover by Roy Krenkel). $9-$11

Burroughs Bulletin #35, fanzine, published by Vern Corriell, March 1974 (cover by Herb Arnold). $10-$12

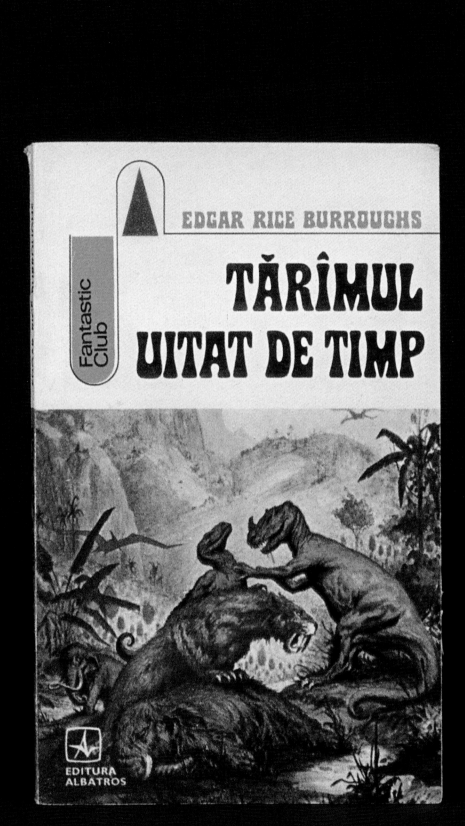

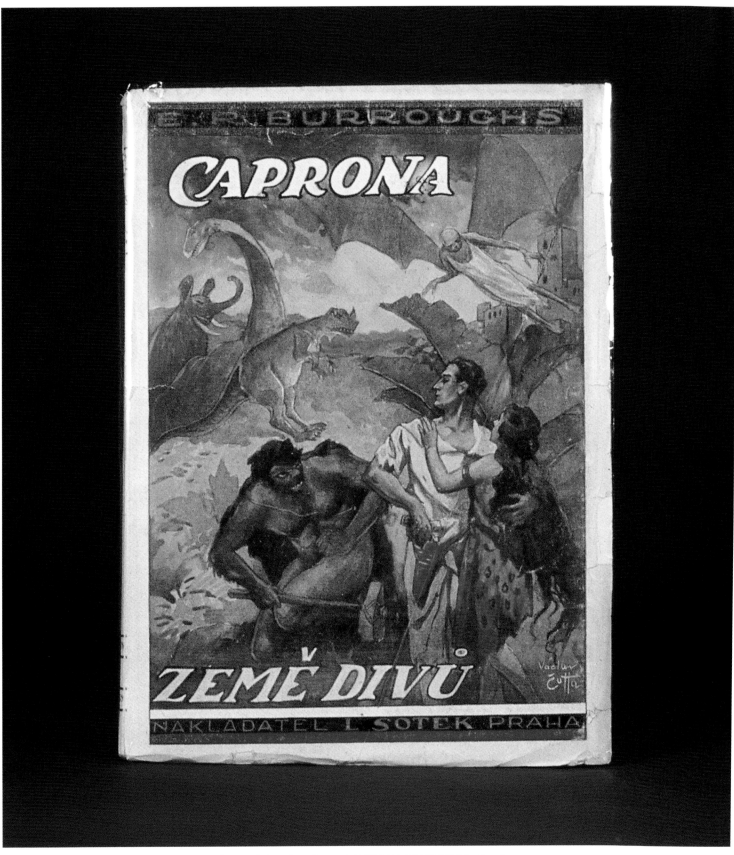

The Land That Time Forgot (CAPRONA ZEME DIVU), Czech
paperback, Sotek, 1926 (cover by Z. Hercik). $75-$95

The Land That Time Forgot, movie
pressbook, AIP, 1974. $12-$15

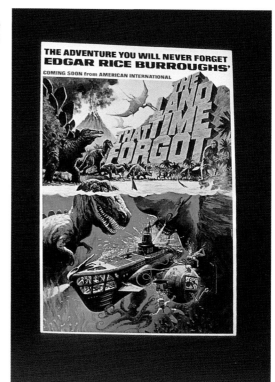

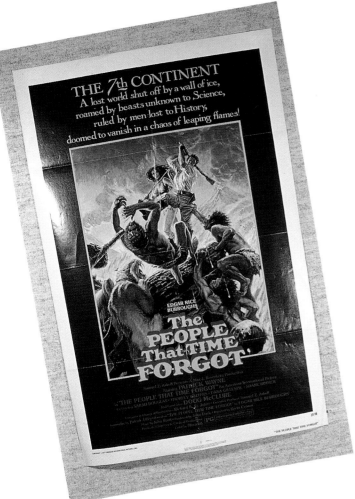

The People That Time Forgot, movie poster
(one sheet, 27 x 41), AIP, 1974. $25-$30

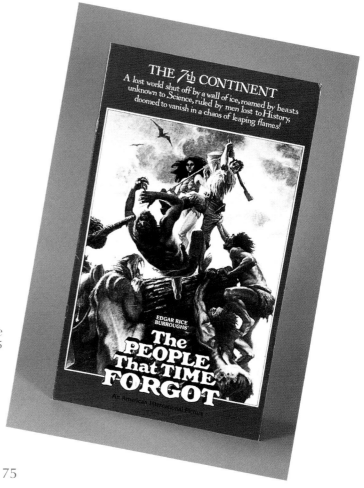

The People That Time Forgot, movie
pressbook, AIP, 1977. $12-$15

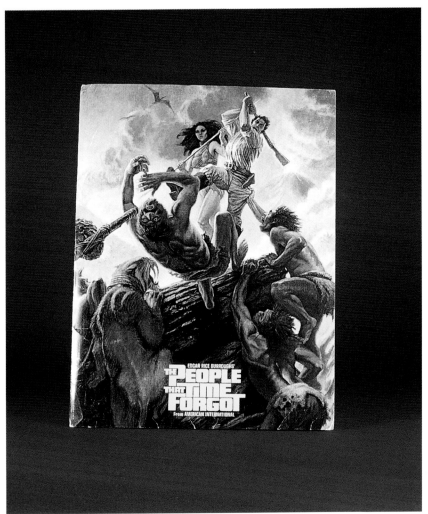

The People That Time Forgot, movie pressbook, AIP, 1974. $12-$15

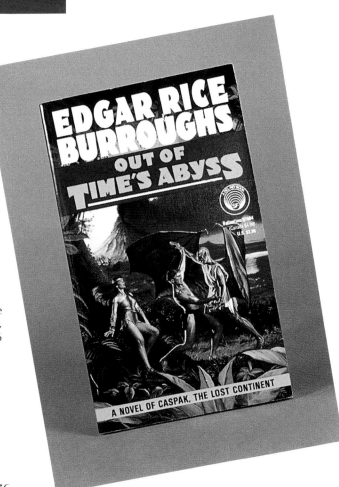

Out of Time's Abyss, paperback, Ballantine #37404, 1992 (cover by Michael Herring). $4-$6

Chapter Seven
Mars

John Carter, Warlord of Mars is the precursor to Tarzan. Both share the same initials (John Clayton being Tarzan's *human* name), a physical description of one can apply to the other, and both have similar attitudes to the world in general—although Carter's world is the red planet Mars, or *Barsoom* in the Martian tongue.

It's in the Martian series that ERB's own opinions on various topics, including religion and politics, are most pronounced. His puckish humor is on display here, more so than in the Tarzan novels.

Under the Moons of Mars (*A Princess of Mars*), pulp magazine (written under the pseudonym "Norman Bean"), *The All-Story*, February 1912 (no cover art). $1,200-$1,500

A Princess of Mars

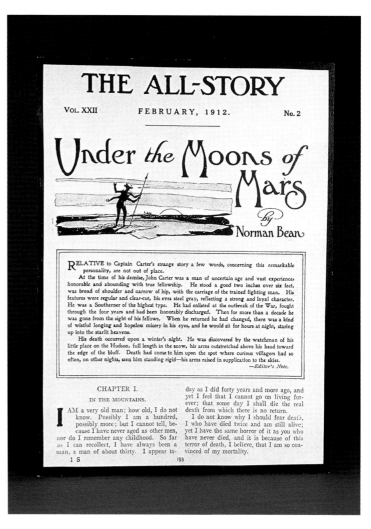

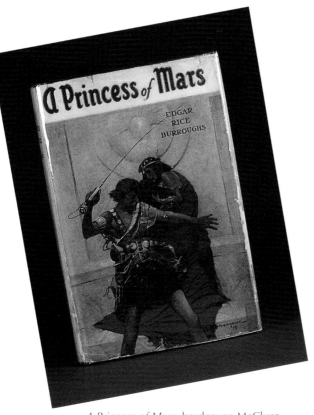

A Princess of Mars, hardcover, McClurg, October 10, 1917 (cover by Frank E. Schoonover). $3,000-$4,500

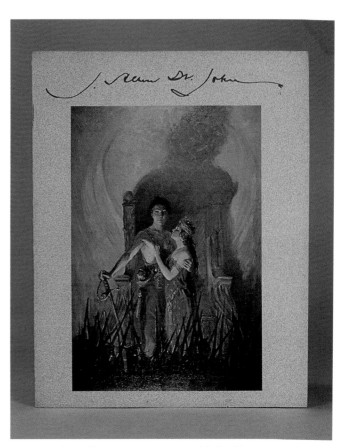

Burroughs Bulletin #25, fanzine, published by Vern Corriell, spring 1972 (cover by J. Allen St. John). $10-$12

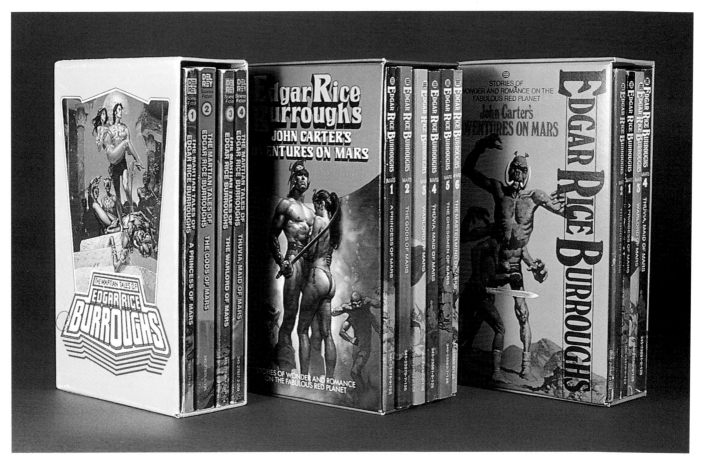

3 Mars Boxed Sets, paperback, DelRey & Ballantine, 1970s/1980s (covers by Michael Whelan & Chris Achilleos). $25-$40

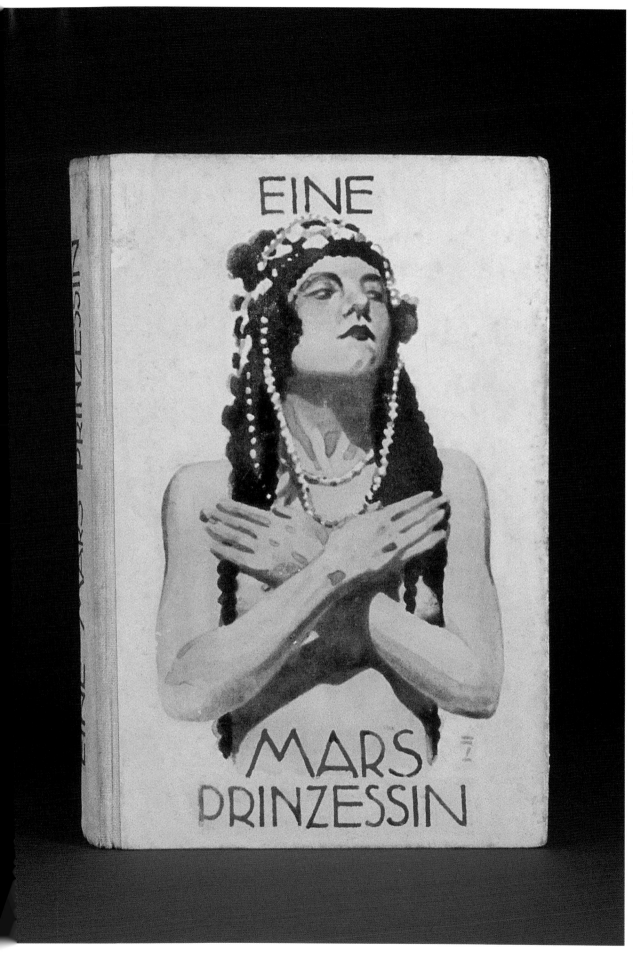

A Princess of Mars (EINE MARS PRINZESSIN), German hardcover, Dieck, 1925 (cover by Ludwig Hohlwein). $200-$350

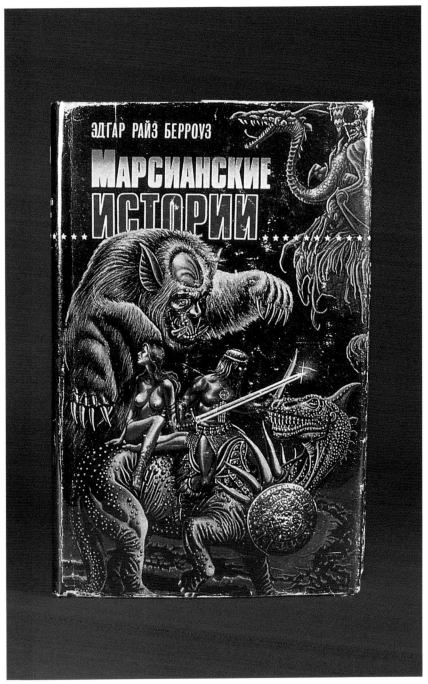

A Princess of Mars, Russian hardcover, Aeterpress, 1991 (cover by A. Stolin). $25-$30

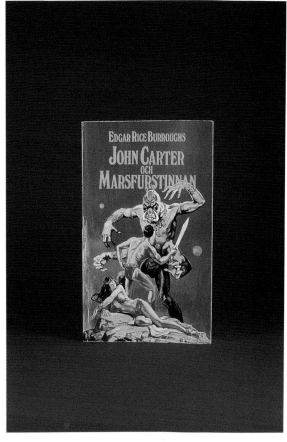

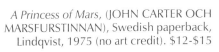

A Princess of Mars, (JOHN CARTER OCH MARSFURSTINNAN), Swedish paperback, Lindqvist, 1975 (no art credit). $12-$15

A Princess of Mars, Finnish magazine, Portti, February 1991 (cover by Kari T. Leppanen). $10-$12

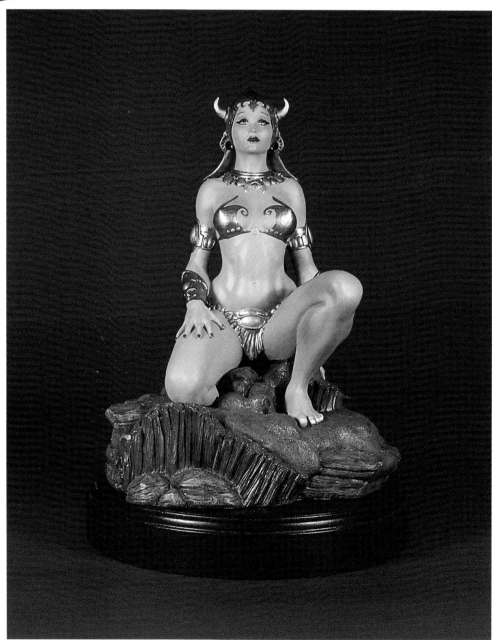

A Princess of Mars-Dejah Thoris, resin figurine (10" high), sculpted by Clayburn Moore (from original art by Frank Frazetta), 1996, #250 of 4,000. $250-$325

The Gods of Mars

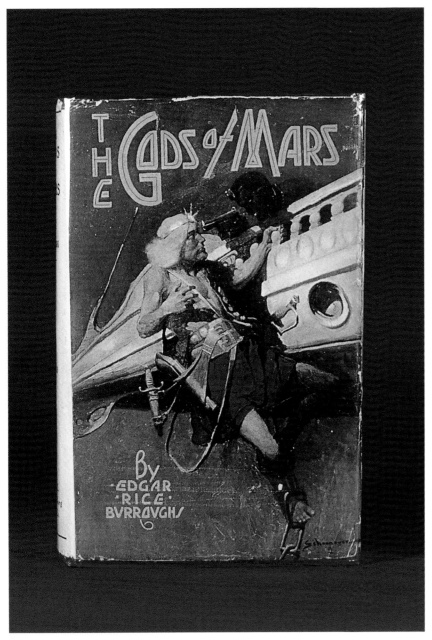

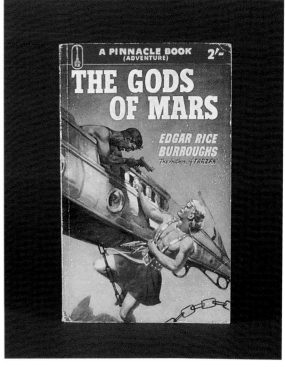

The Gods of Mars, hardcover (first appeared in pulp magazine, *The All-Story*, January 1913, no cover art), McClurg, September 28, 1918 (cover by Frank E. Schoonover). $2,500-$4,000

Opposite page:
The Gods of Mars (JOHN CARTER OCH GUDARNA PA MARS), Swedish paperback (printed in Finland, published in Barcelona), Lindqvist, 1975 (no art credit). $7-$10

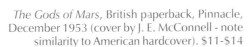

The Gods of Mars, British paperback, Pinnacle, December 1953 (cover by J. E. McConnell - note similarity to American hardcover). $11-$14

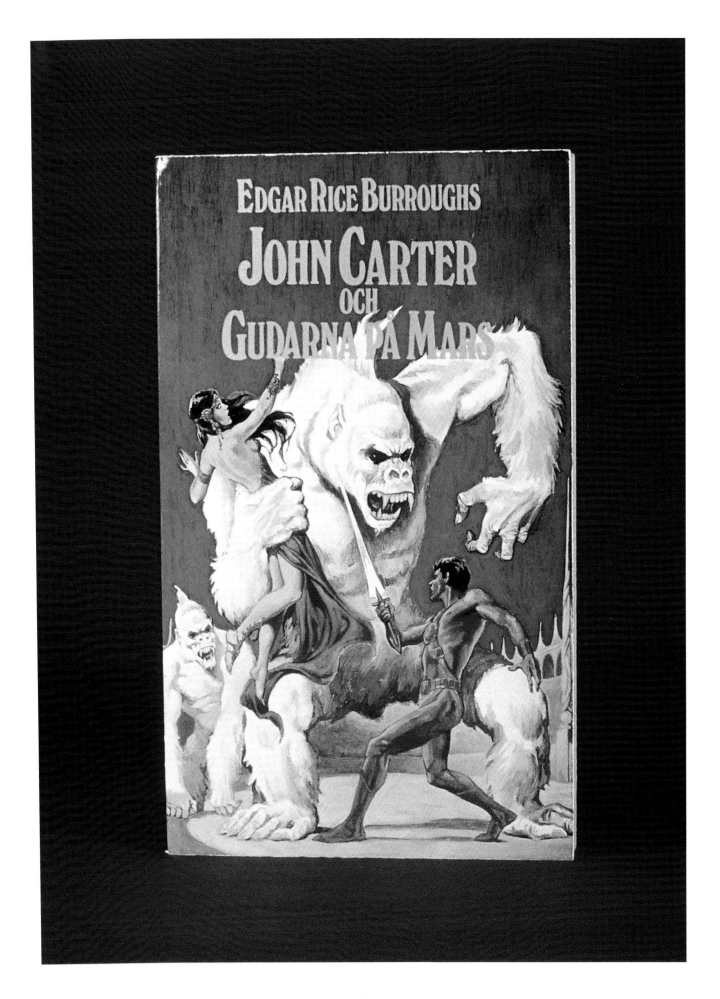

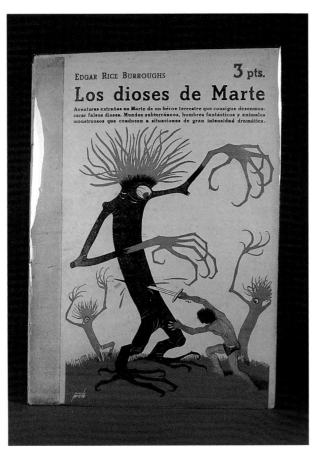

The Gods of Mars (LOS DIOS DE MARTE), Spanish paperback, Revista Literaria, March 2, 1947 (cover by Manolo Prieto). $9-$11

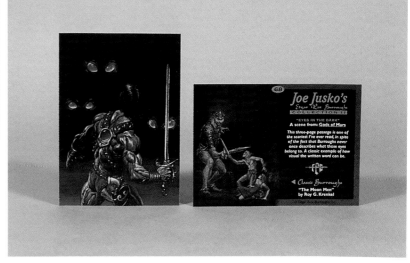

Eyes in the Dark - The Moon Men, trading card (both sides), FPG, 1995 (art by Joe Jusko & Roy Krenkel). 25 cents

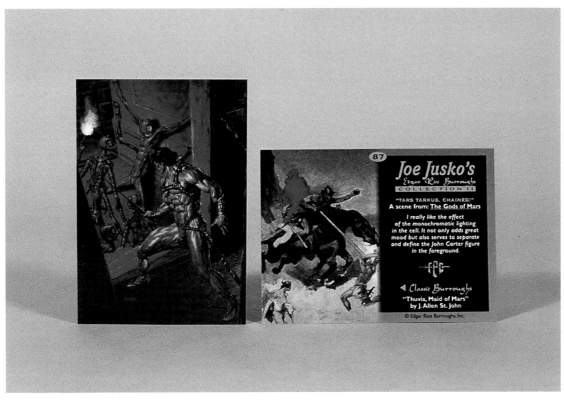

Tars Tarkas, Chained/ Thuvia, Maid of Mars, trading card (both sides), FPG, 1995 (art by Joe Jusko & J. Allen St. John). 25 cents

The Warlord of Mars

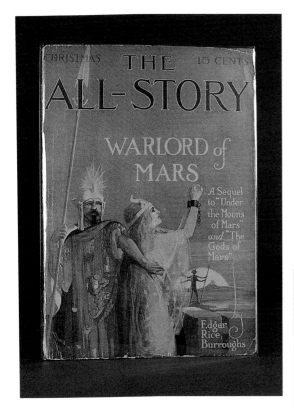

The Warlord of Mars, pulp magazine, *The All-Story*, December 1913 (cover by F. W. Small). $180-$220

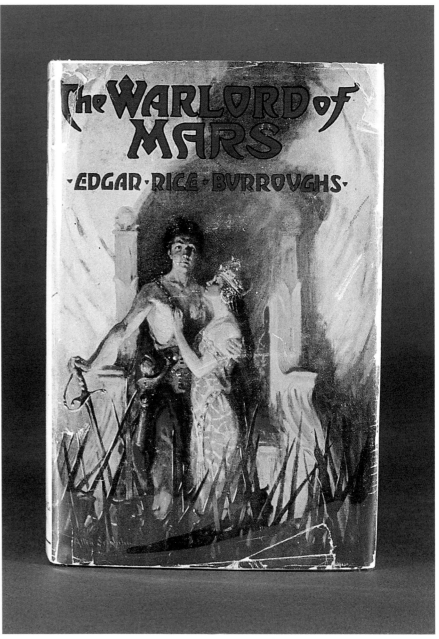

The Warlord of Mars, hardcover, McClurg, September 27, 1919 (cover by J. Allen St. John). $2,300-$3,500

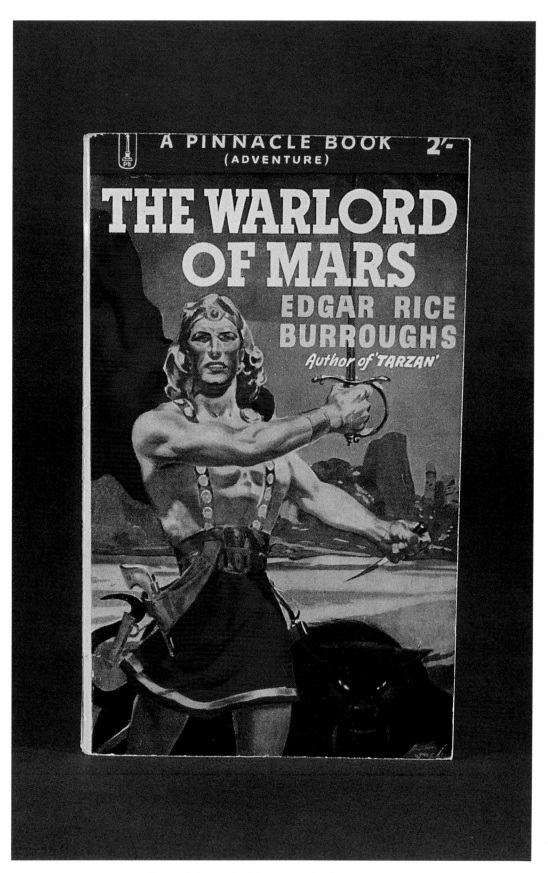

The Warlord of Mars, British paperback, Pinnacle,
September 1953 (cover by J. E. McConnell). $20-$30

Thuvia, Maid of Mars

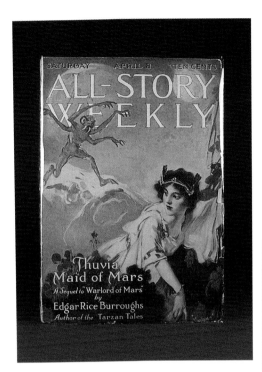

Thuvia, Maid of Mars, pulp magazine, *All-Story Weekly*, April 8, 1916 (cover by P. J. Monahan). $180-$220

Thuvia, Maid of Mars, hardcover, McClurg, October 30, 1920 (cover by P. J. Monahan). $1,000-$1,700

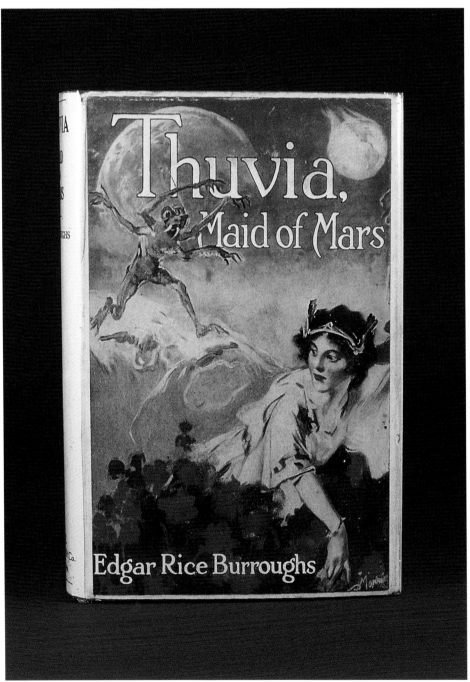

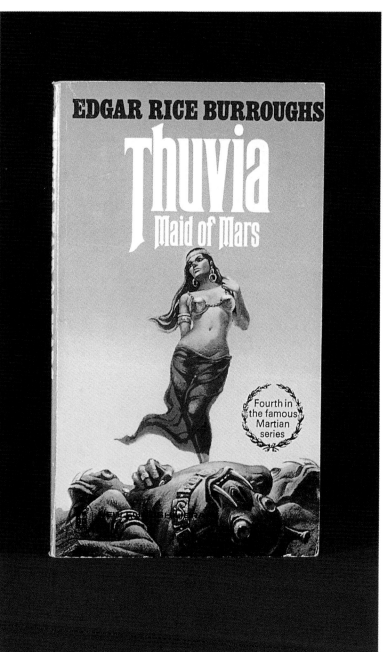

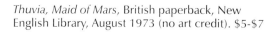
Thuvia, Maid of Mars, British paperback, New English Library, August 1973 (no art credit). $5-$7

Opposite page:
The Chessmen of Mars, pulp magazine, *Argosy All-Story Weekly*, February 18, 1922 (cover by P. J. Monahan). $125-$170

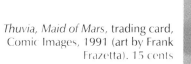
Thuvia, Maid of Mars, trading card, Comic Images, 1991 (art by Frank Frazetta). 15 cents

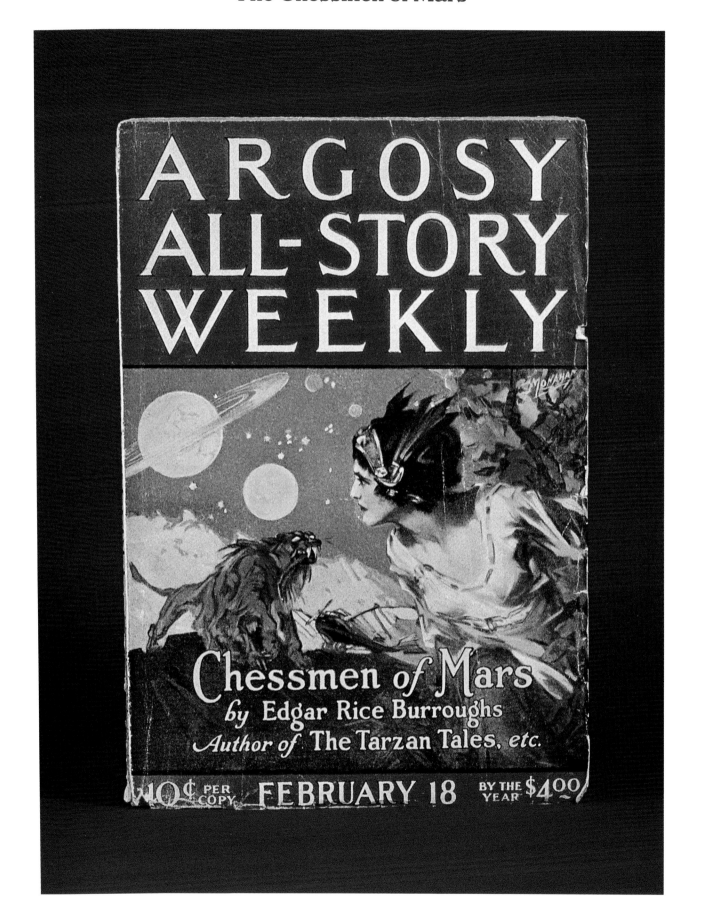

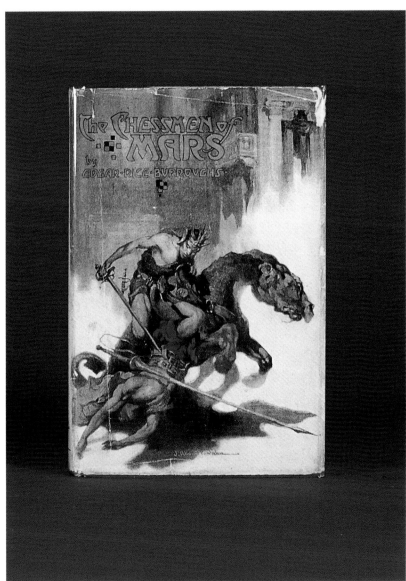

The Chessmen of Mars, hardcover, McClurg, November 29, 1922 (cover by J. Allen St. John). $1,100-$1,700

The Chessmen of Mars, paperback, Ballantine #27838, 1980 (cover by Michael Whelan). $4-$6

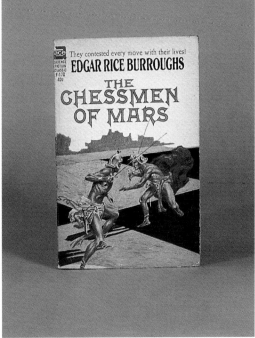

The Chessmen of Mars, paperback, Ace #F-170, undated (cover by Roy Krenkel). $7-$9

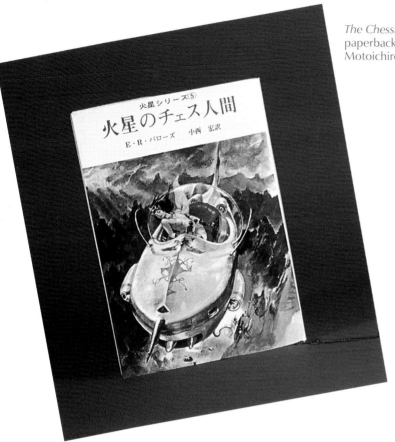

The Chessmen of Mars, Japanese paperback, Hayakawa, 1971 (cover by Motoichiro Takebe). $9-$11

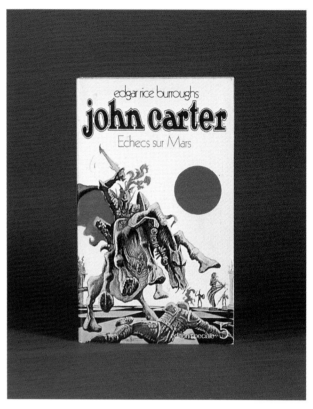

The Chessmen of Mars (ECHECS SUR MARS), French paperback, Edition Speciale, 1971 (cover by Phillipe Druillet). $7-$9

The Battle of the Kings/ The Chessmen of Mars, trading card (both sides), FPG, 1995 (art by Joe Jusko & Roy Krenkel). 25 cents

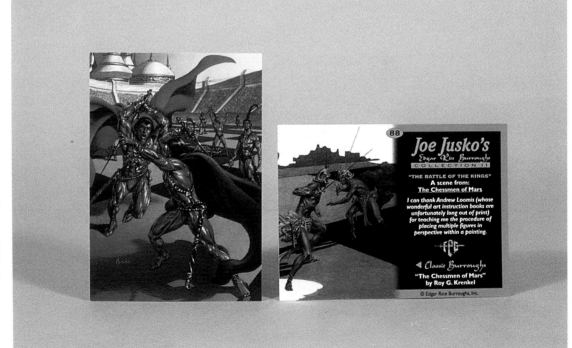

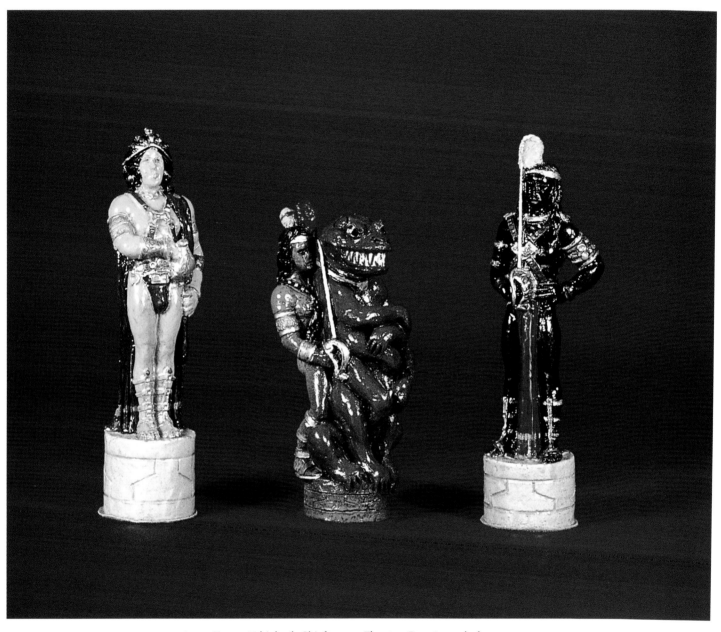

Jetan Pieces, 6" high, (l. *Chieftan*, m. *Thoat*, r. *Dwar*), made from crushed pecan shells by James Killian Spratt, 1997, only five sets made. $500

Opposite page:
The Master Mind of Mars, pulp magazine, *Amazing Stories Annual*, 1927 (cover by Frank R. Paul). $200-$250

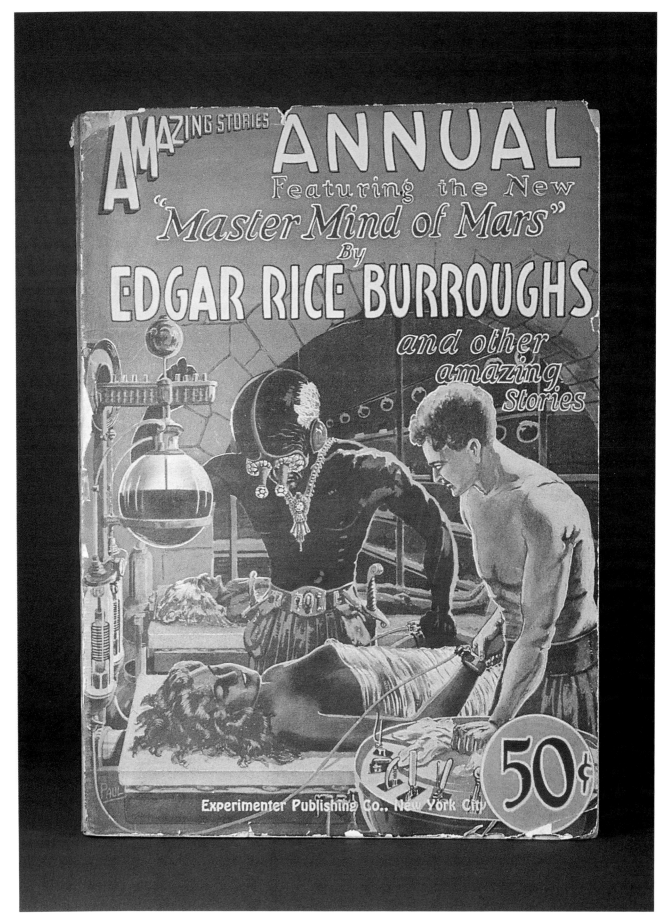

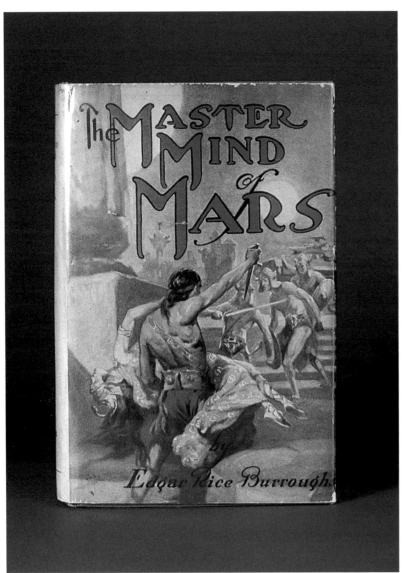

The Master Mind of Mars, hardcover, McClurg, March 10, 1928 (cover by J. Allen St. John). $1,200-$1,800

The Master Mind of Mars, British hardcover, Methuen, 1952 (cover by G. P. Micklewright). $60-$80

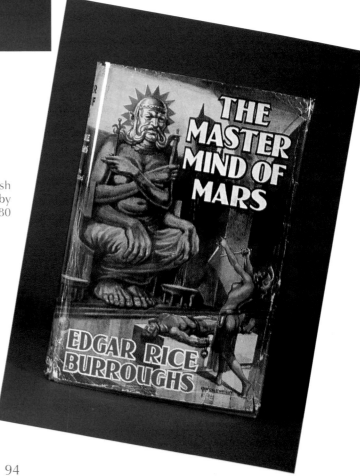

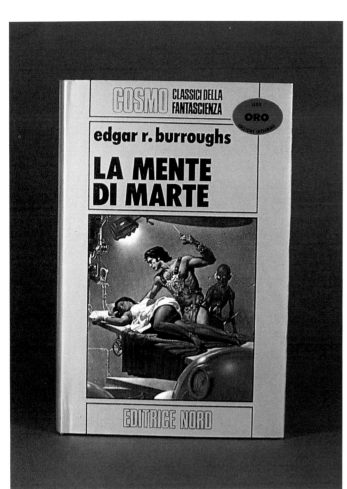

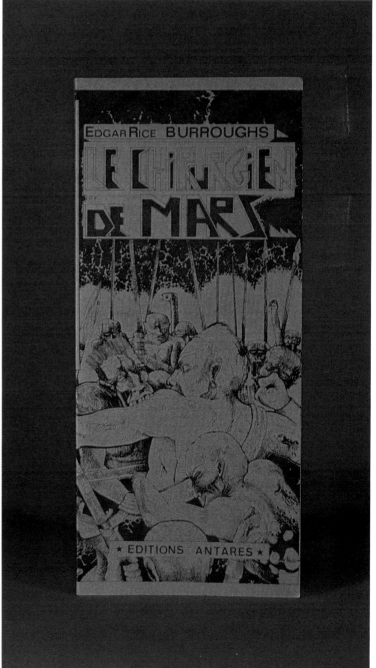

The Master Mind of Mars (LA MENTE DI MARTE), Italian hardcover, Cosuo, 1981 (cover by Michael Whelan). $8-$10

The Master Mind of Mars (LE CHIRURGIEN DE MARS), French paperback, Antares, 1984 (cover by Robert Borello). $7-$9

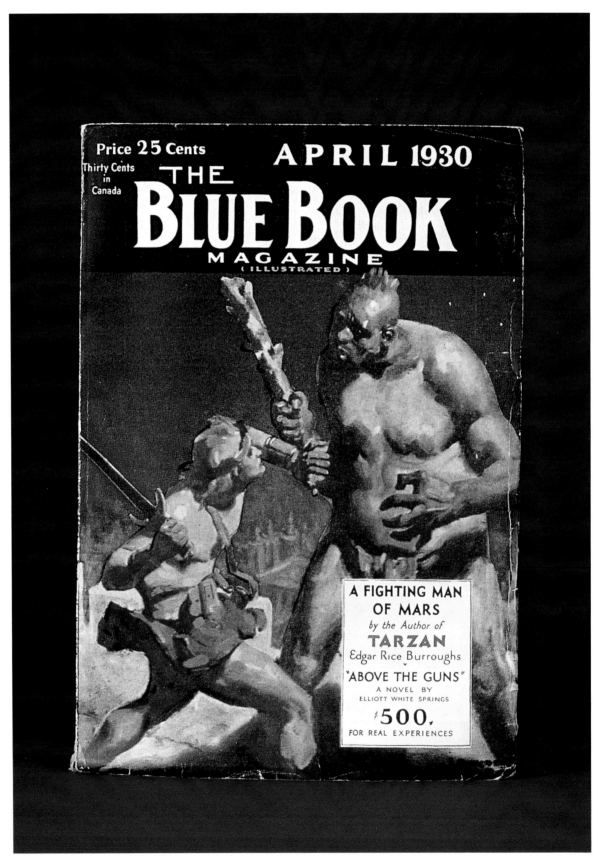

A Fighting Man of Mars, pulp magazine, *The Blue Book*,
April 1930 (cover by Laurence Herndon). $55-$65

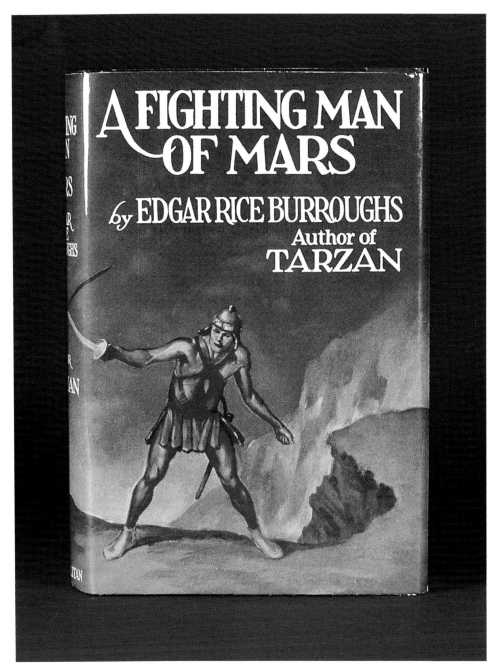

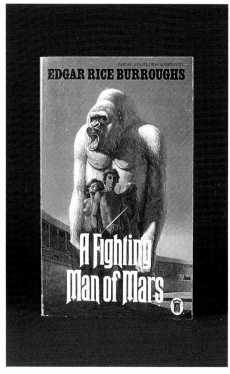

A Fighting Man of Mars, British paper-back, New English Library, October 1971 (no art credit). $7-$9

A Fighting Man of Mars, hardcover, Metropolitan, May 15, 1931 (cover by Hugh Hutton). $1,000-$1,500

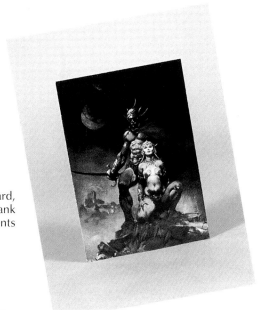

A Fighting Man of Mars, trading card, Comic Images, 1991 (art by Frank Frazetta). 15 cents

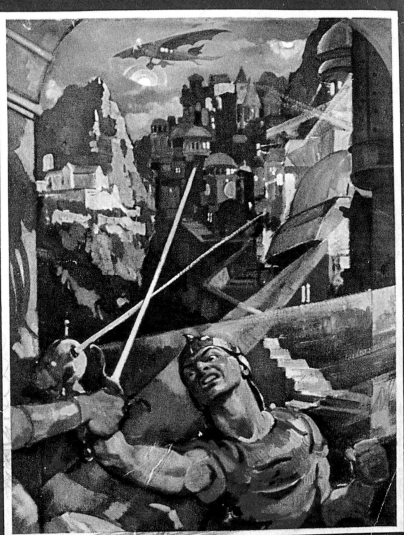

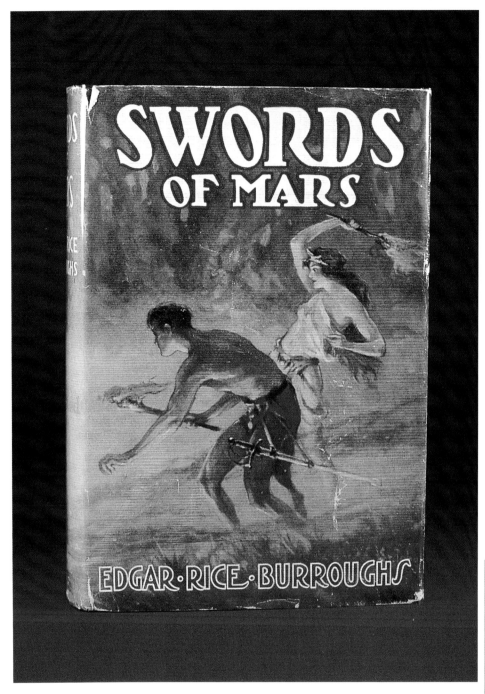

Swords of Mars, hardcover, Burroughs, February 15, 1936 (cover by J. Allen St. John). $500-$700

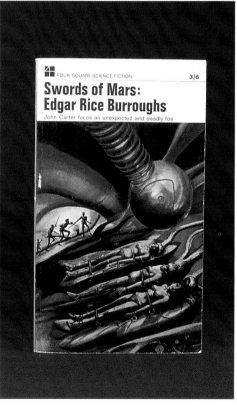

Swords of Mars, British paperback, Four Square, December 1966 (no art credit). $7-$9

Opposite page:
Swords of Mars, pulp magazine, second installment, (first installment of November 1934 had no cover art), *Blue Book*, December 1934 (cover by Joseph Chenoweth). $25-$35

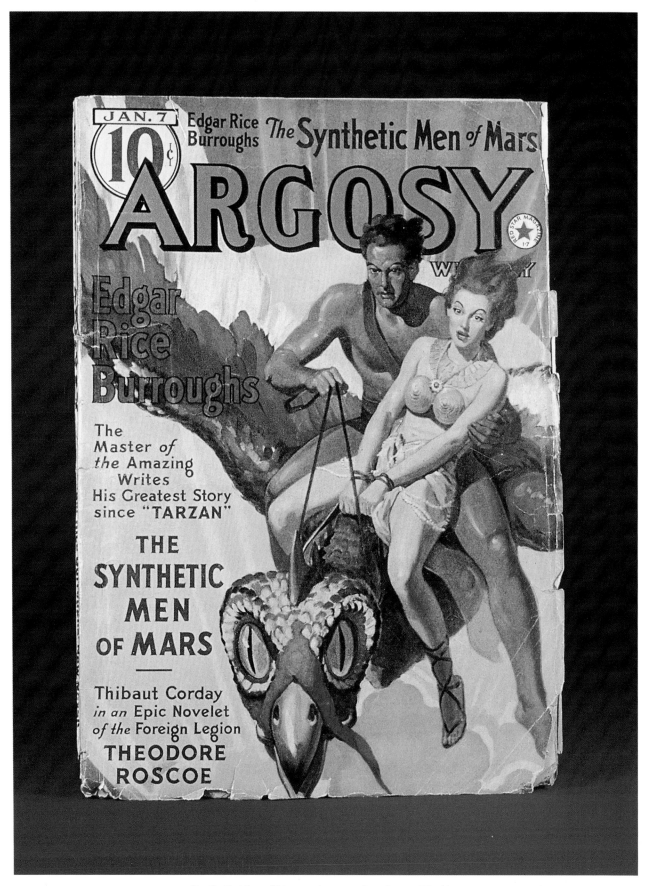

Synthetic Men of Mars, pulp magazine, *Argosy Weekly*,
January 7, 1939 (cover by Rudolph Belarski). $45-$55

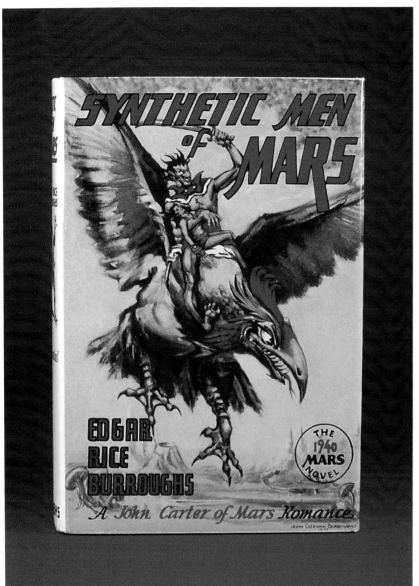

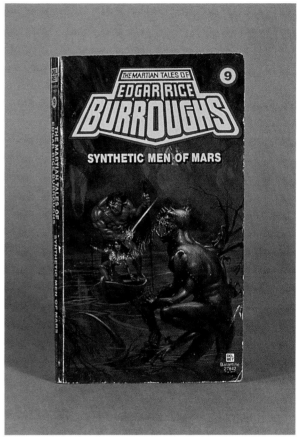

Synthetic Men of Mars, hardcover, Burroughs, March 15, 1940 (cover by John Coleman Burroughs). $400-$600

Synthetic Men of Mars, paperback, Ballantine #27842, 1979 (cover by Michael Whelan). $4-$6

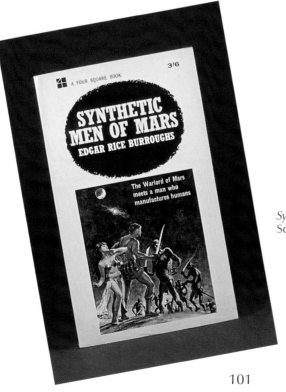

Synthetic Men of Mars, British paperback, Four Square, November 1964 (no art credit). $5-$7

Llana of Gathol

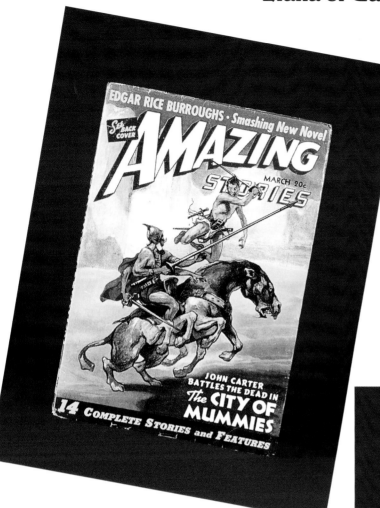

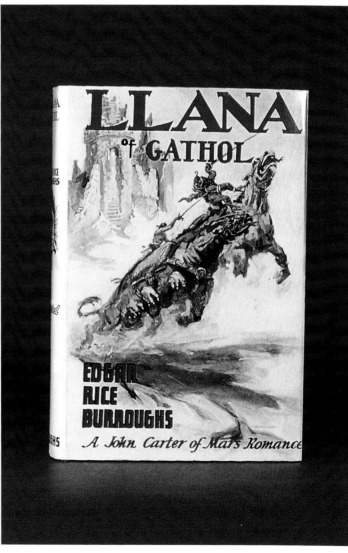

The City of Mummies (*Llana of Gathol*), pulp magazine, *Amazing Stories*, March 1941 (cover by J. Allen St. John). $40-$50

Llana of Gathol, hardcover, Burroughs, March 26, 1948 (cover by John Coleman Burroughs). $150-$200

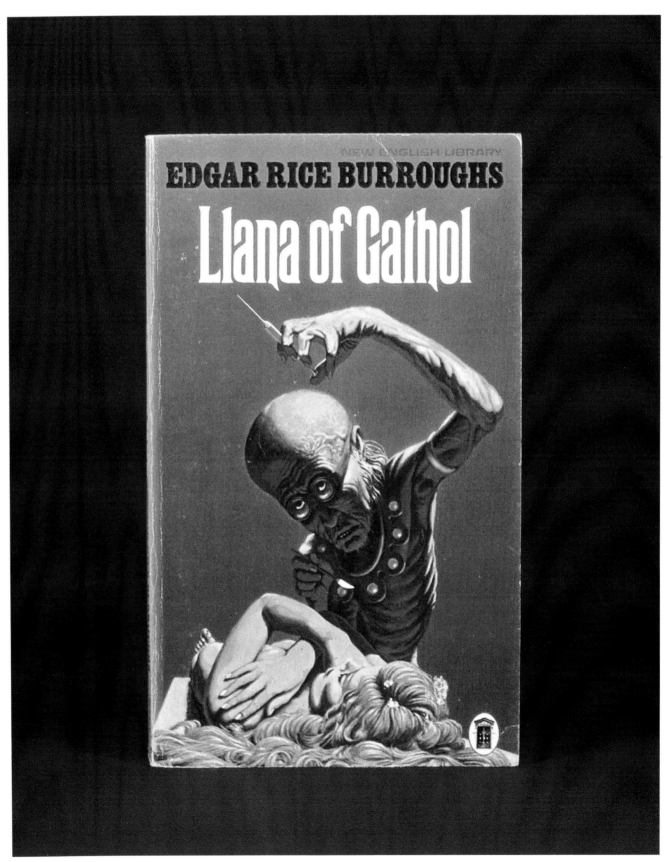

Llana of Gathol, British paperback, New English
Library, 1971 (no art credit). $7-$9

John Carter of Mars

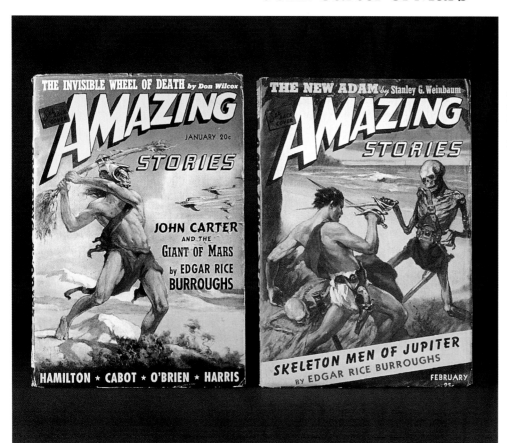

John Carter & The Giant of Mars/ Skeleton Men of Jupiter, pulp magazines, *Amazing Stories*, January & February 1941 (both covers by J. Allen St. John). $40-$50 each

John Carter of Mars, hardcover, Canaveral, July 24, 1964 (cover by Reed Crandall). $80-$120

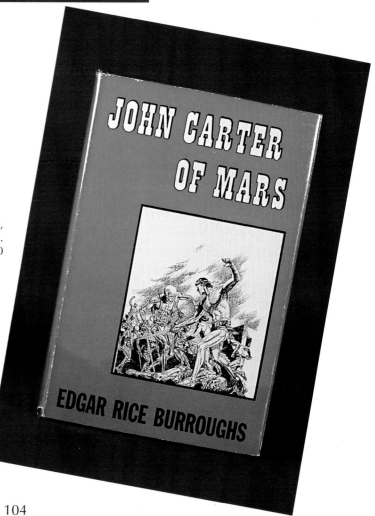

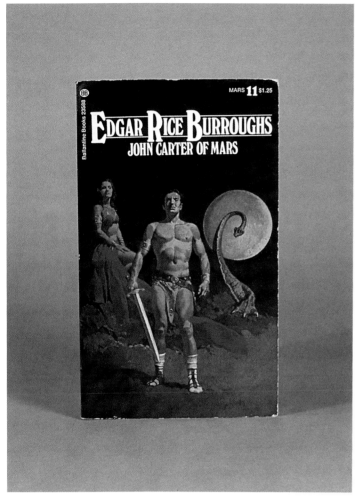

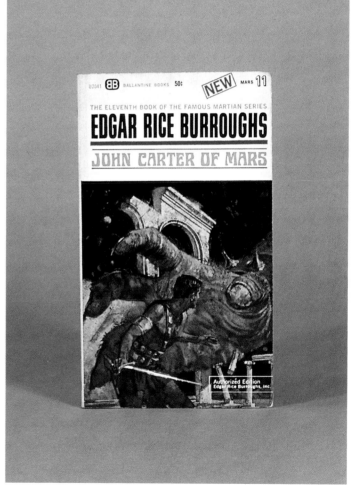

John Carter of Mars, paperback, Ballantine #U-2041, 1964 (no art credit - Bob Abbett?). $4-$6

John Carter of Mars, paperback, Ballantine #23588, 1973 (cover by Gino D'Achille). $4-$6

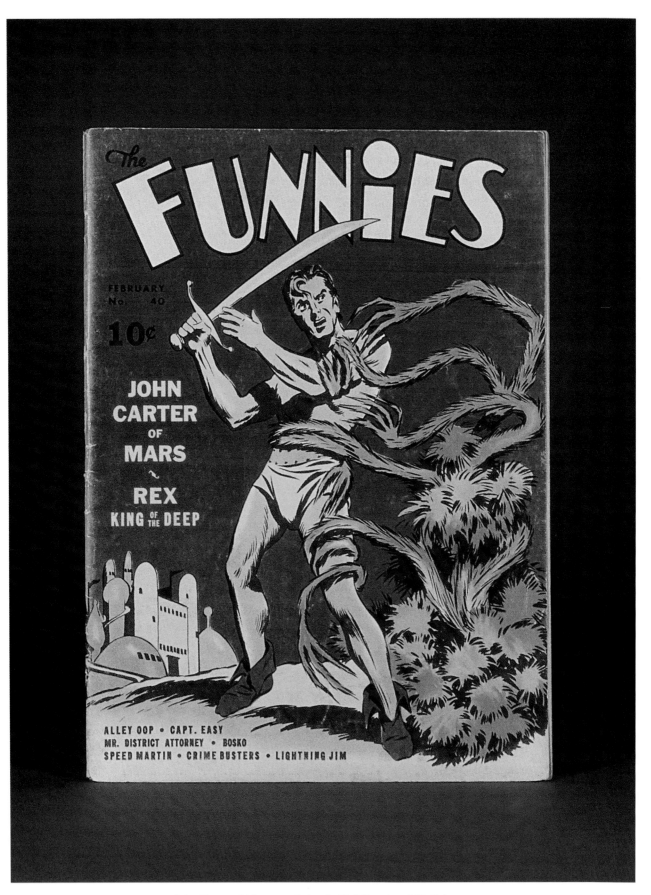

John Carter of Mars, comic book, Dell Funnies #40, February
1940 (art by John Coleman Burroughs). $250-$350

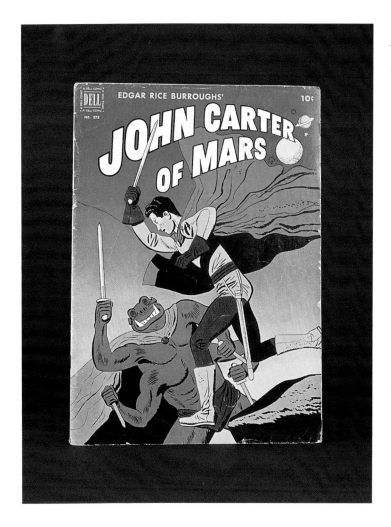

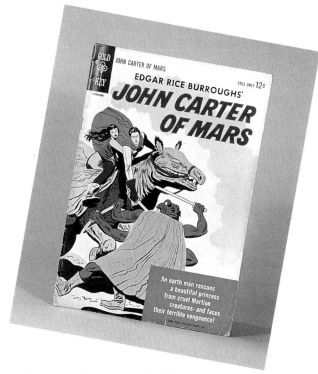

John Carter of Mars, comic book, Dell Four Color #375, 1952 (art by Jesse Marsh). $100-$200

John Carter of Mars, comic book, Gold Key #1, 1964 (art by Jesse Marsh). $20-$30

John Carter of Mars, comics, House of Greystoke (reprints of 1940s strips), 1970 (art by John Coleman Burroughs). $45-$60

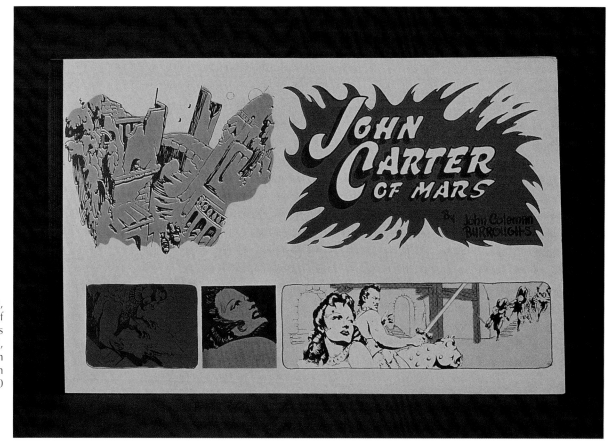

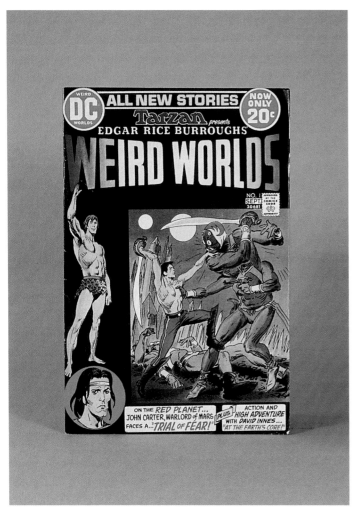

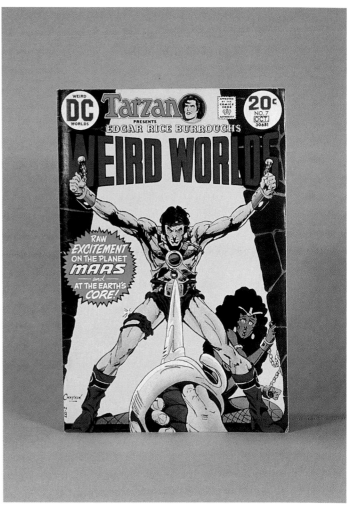

Weird Worlds, comic book, DC #1, September 1972 (cover by Joe Kubert). $4-$6

Weird Worlds, comic book, DC #7, October 1973 (cover by Howard Chaykin). $4-$6

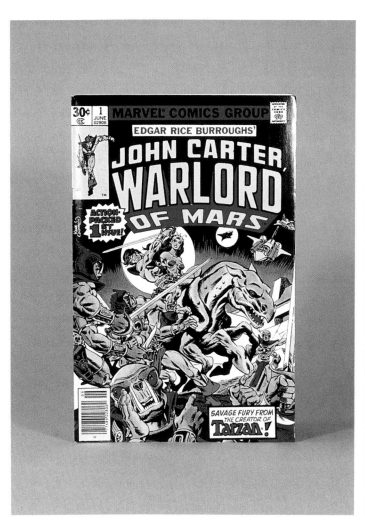

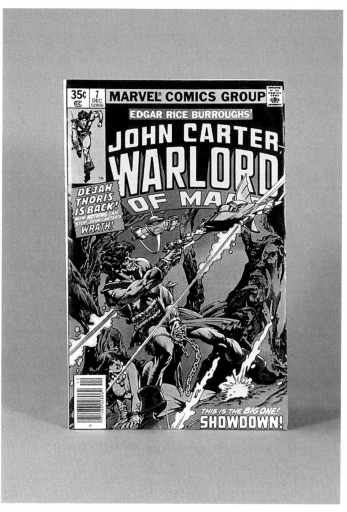

John Carter, Warlord of Mars, comic book, Marvel #1, June 1977 (cover by Gil Kane & David Cockrum). $4-$6

John Carter, Warlord of Mars, comic book, Marvel #7, December 1977 (no art credit - Kane & Nebres?). $4-$6

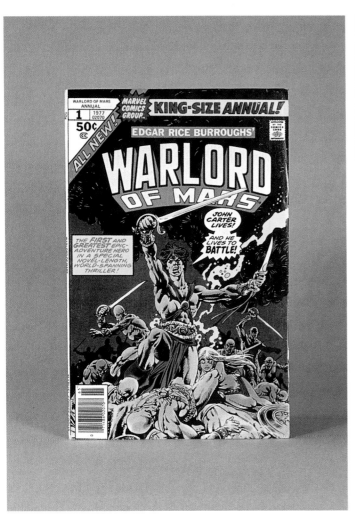

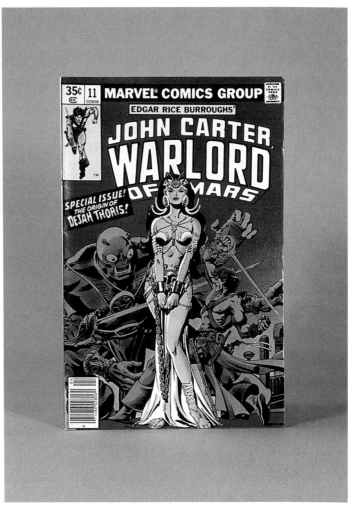

John Carter, Warlord of Mars, comic book, Marvel Annual #1, 1977 (no art credit - Kane & Nebres?). $4-$6

John Carter, Warlord of Mars, comic book, Marvel #11, April 1978 (no art credit - Kane & Nebres?). $4-$6

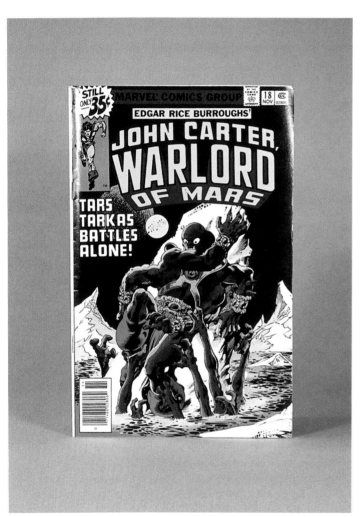

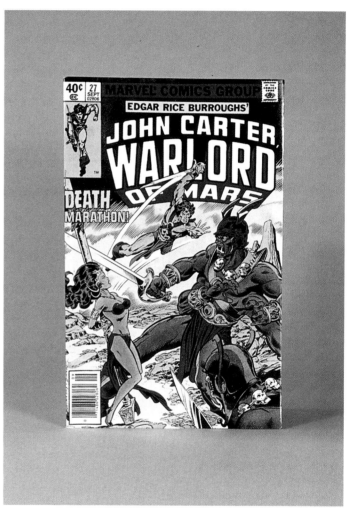

John Carter, Warlord of Mars, comic book, Marvel #18, November 1978 (no art credit). $4-$6

John Carter, Warlord of Mars, comic book, Marvel #27, September 1979 (no art credit). $4-$6

Opposite page:
ERB-dom #44, fanzine, published by Camille
Cazedessus, Jr., March 1971 (cover by Eddie
Jones). $10-$12

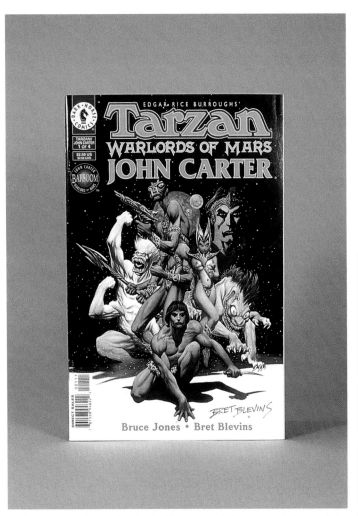

Tarzan/John Carter, Warlord of Mars, comic book, Dark Horse #1,
January 1996, (cover by Brett Bleding). $3-$4

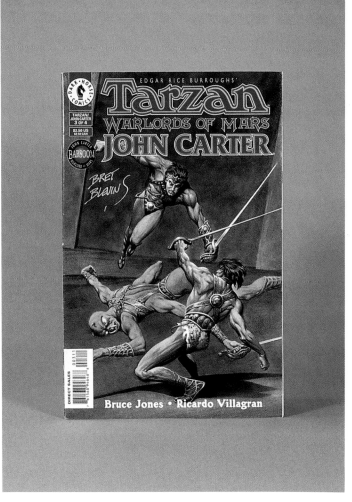

Tarzan/John Carter, Warlord of Mars, comic book, Dark Horse #3,
May 1996 (cover by Brett Bleding). $3-$4

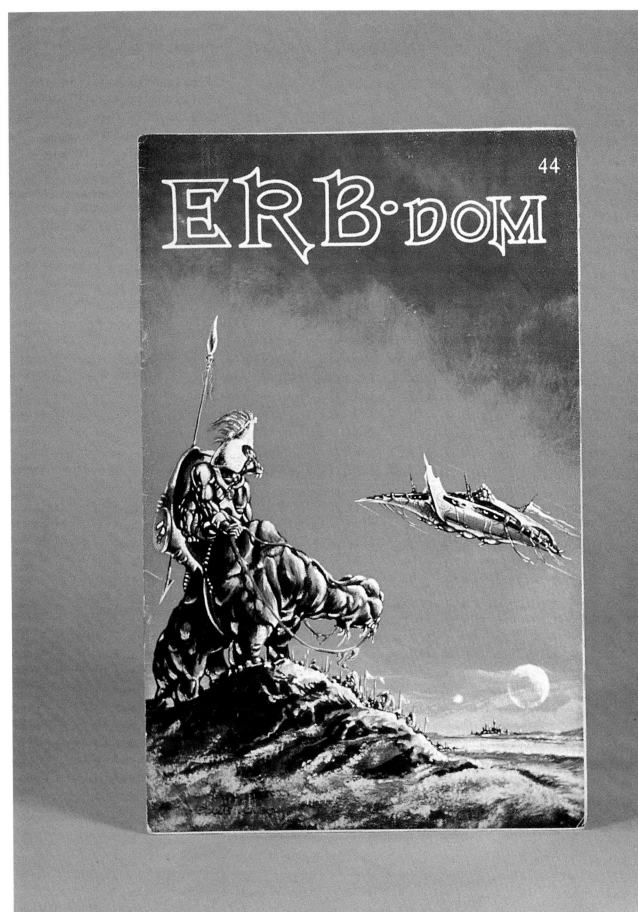

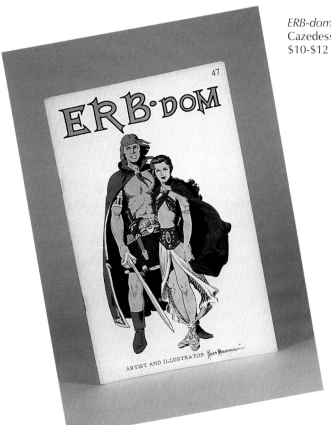

ERB-dom #47, fanzine, published by Camille Cazedessus, Jr., June 1971 (cover by Russ Manning). $10-$12

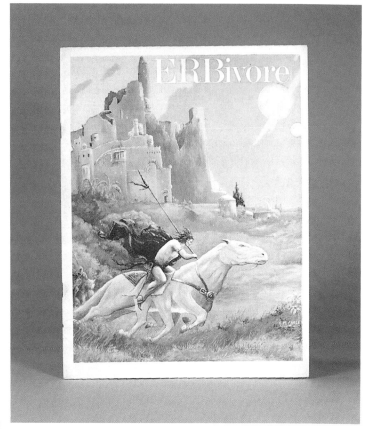

ERBivore #6-7, fanzine, published by Philip J. Curie, August 1973 (cover by G. M. Farley). $10-$12

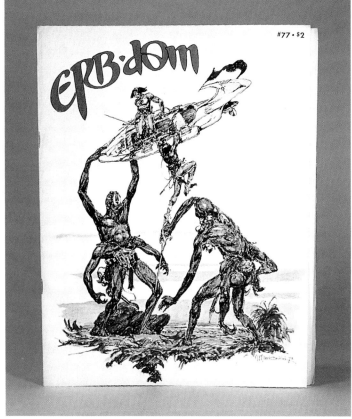

ERB-dom #77, fanzine, published by Camille Cazedessus, Jr., June 1974 (cover by Neal MacDonald). $10-$12

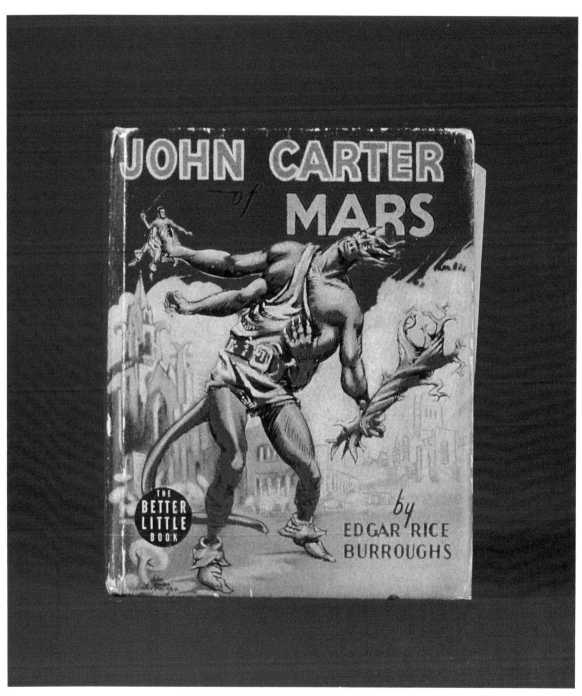

John Carter of Mars, Better Little Book #1402, Whitman
Publishing, 1940 (art by John Coleman Burroughs). $50-$75

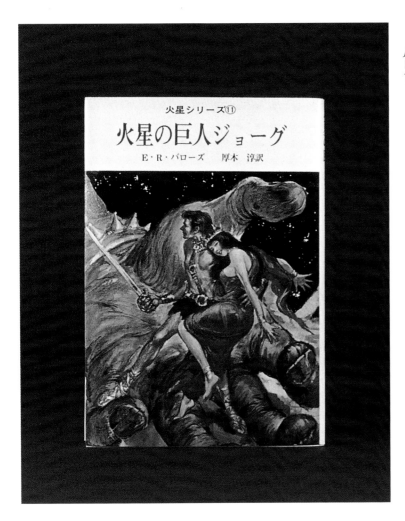

John Carter of Mars, Japanese paperback,
Hayakawa, 1970 (cover by Motoichiro
Takebe). $9-$11

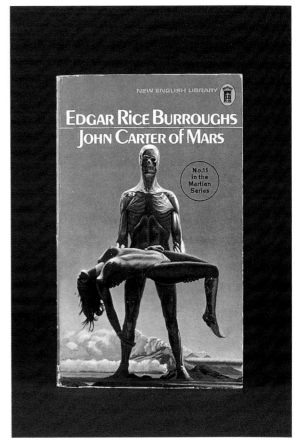

John Carter of Mars, British paperback, New English
Library, August 1972 (no art credit). $6-$7

John Carter of Mars, trading card, FPG,
1992 (art by Ken Kelly). 15 cents

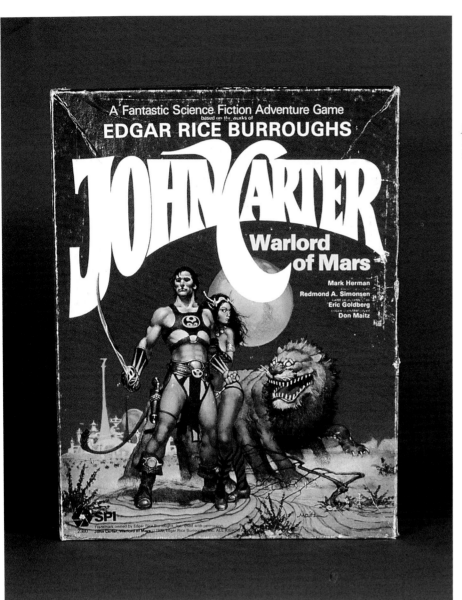

John Carter, Warlord of Mars, game, Simulations Publications, Inc., 1979 (art by Don Maitz). $25-$35

Tars Tarkas, plastic action figure (app. 9" high), Trendmasters, 1995. $6-$8

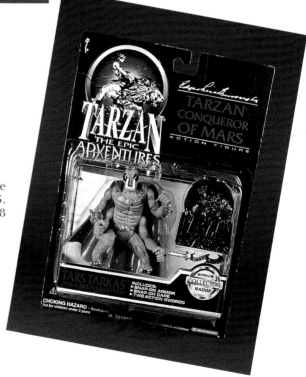

117

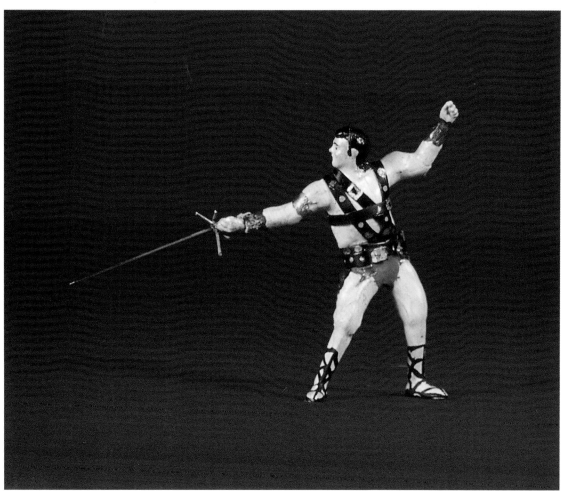

John Carter, painted figurine (3" high), unknown material and maker, ca 1930s. $75-$125

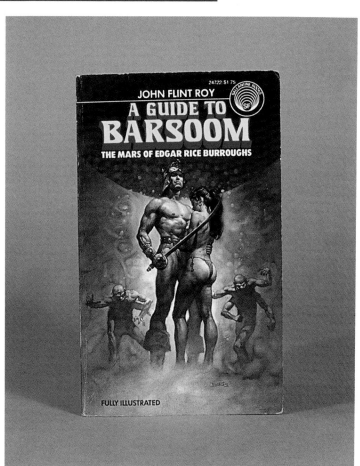

A Guide to Barsoom, paperback, by John Flint Roy, Ballantine #24722 (cover by Boris Vallejo). $8-$10

Chapter Eight
Miscellaneous

This category shows the enormous range of Burroughs' writing and interests. Contemporary stories (to ERB's time) vie with *lost land* tales. In several of these stories, Burroughs returns to the jungle, a place he never visited, except in his and others' books. The final book in this section, *Minidoka*, first published nearly fifty years after his death, contains artwork by dozens of ERB's illustrators, including Burroughs himself.

The Cave Girl

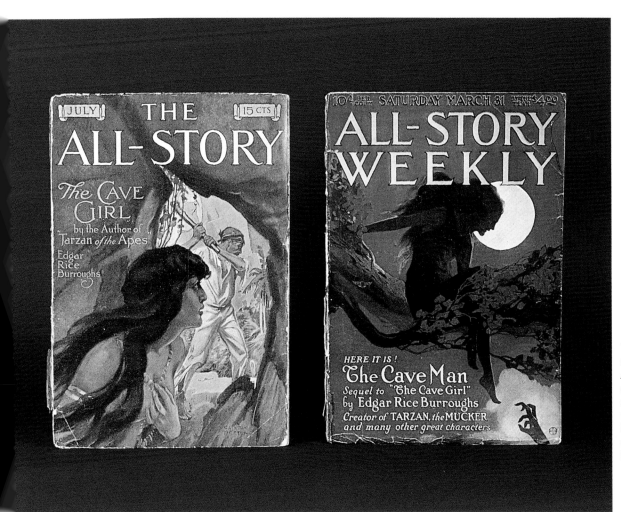

The Cave Girl/The Cave Man, pulp magazines, *All-Story*, July 1913 and *All-Story Weekly*, March 31, 1917 (covers by Clinton Pettee & P. J. Monahan). $100-$125/$85-$100

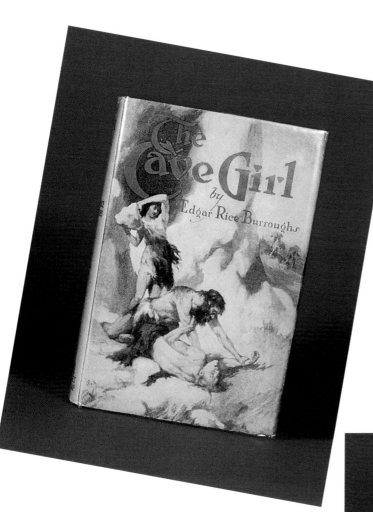

The Cave Girl, hardcover, McClurg, March 21, 1925 (cover by J. Allen St. John). $1,500-$2,000

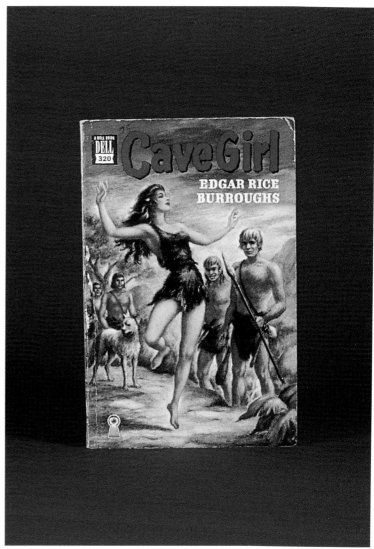

The Cave Girl, paperback, Dell #320, August 1949, (cover by Jean des Vignes). $40-$60

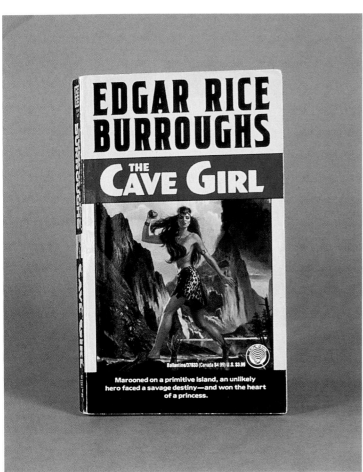

The Cave Girl, paperback, Ballantine #37833, 1992 (cover by Michael Herring). $6-$8

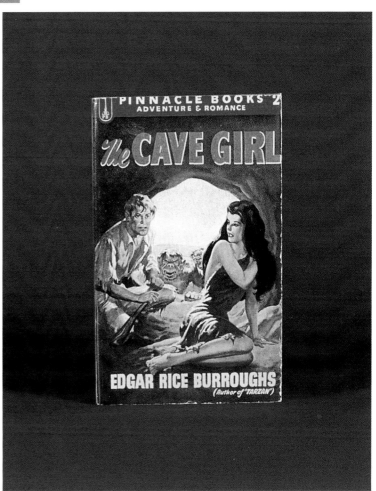

The Cave Girl, British paperback, Pinnacle, June 1954 (cover by J. E. McConnell). $10-$20

The Monster Men

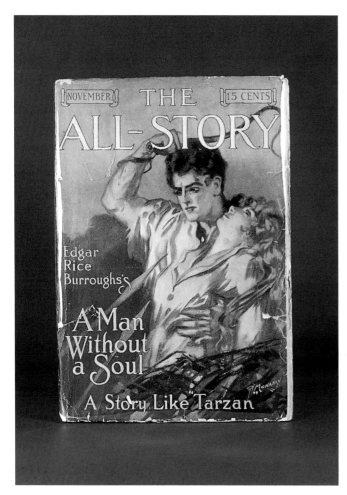

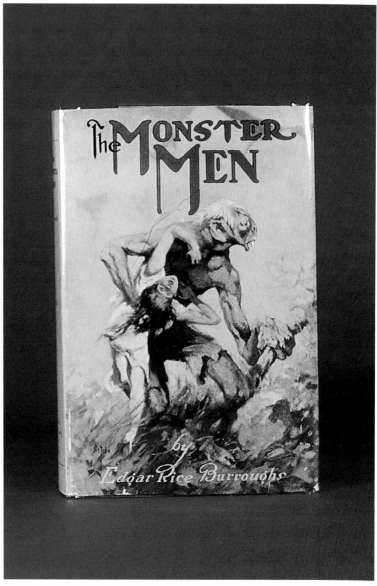

A Man Without a Soul (*The Monster Men*), pulp magazine, *The All-Story*, November 1913 (cover by P. J. Monahan). $125-$150

The Monster Men, hardcover, McClurg, March 15, 1929 (cover by J. Allen St. John). $1,500-$2,000

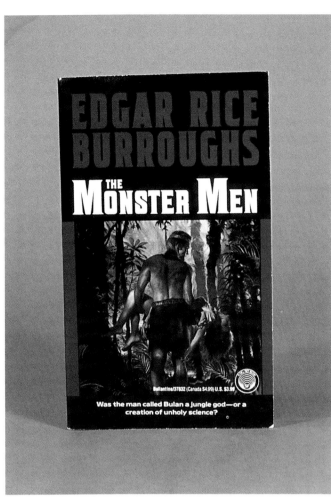

The Monster Men, paperback, Ballantine #37832, 1992 (cover by Michael Herring). $4-$6

The Monster Men, British paperback, Tandem, 1976 (no art credit). $5-$7

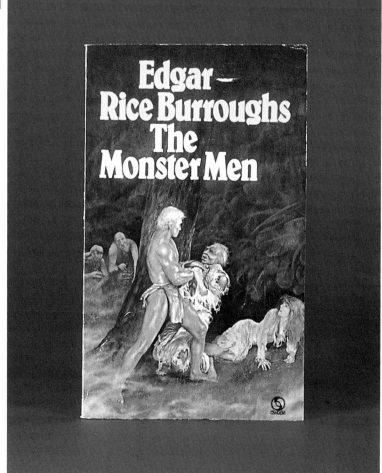

Number One (*The Monster Men*), trading card, Comic Images, 1993 (art by William Stout). 15 cents

The Monster Men, trading card, FPG, 1995 (art by Jeffrey Jones). 15 cents

The Eternal Lover

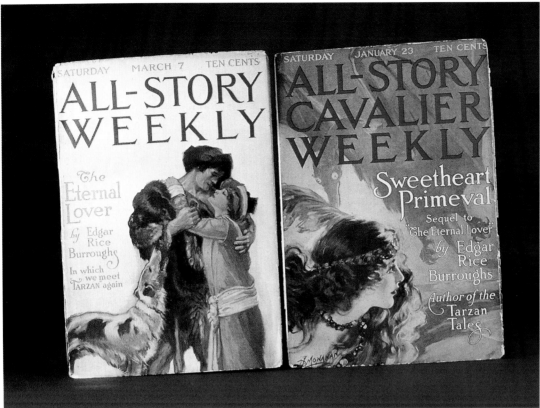

The Eternal Lover/Sweetheart Primeval, pulp magazines, *All-Story Weekly*, March 7, 1914 and *All-Story Cavalier Weekly*, January 1915 (covers by Stockton Milford? & P. J. Monahan). $125-$140/$120-

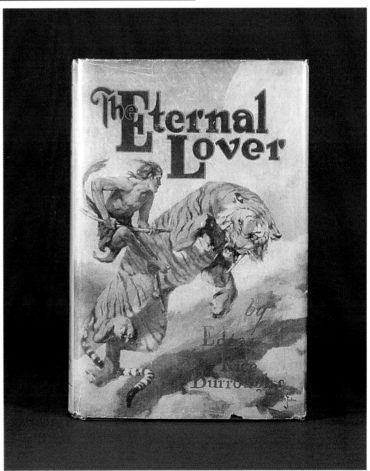

The Eternal Lover, hardcover (contains *The Eternal Lover & Sweetheart Primeval*), McClurg, October 3, 1925 (cover by J. Allen St. John). $1,500-$2,200

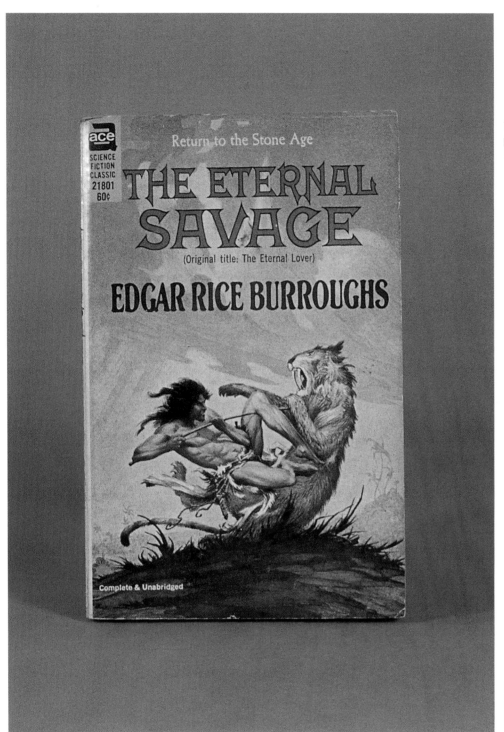

The Eternal Savage (*The Eternal Lover*), paperback, Ace #21801, undated (cover by Roy Krenkel). $6-$8

The Eternal Lover, British paperback, Pinnacle, October 1953 (cover by J. E. McConnell). $15-$20

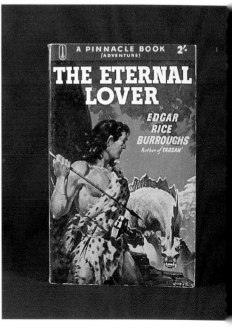

The Mucker/Return of the Mucker

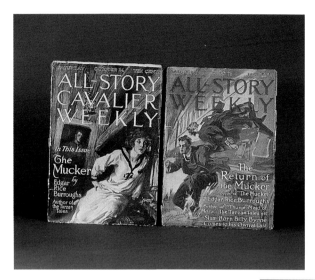

The Mucker/Return of the Mucker, pulp magazines, *All-Story Cavalier Weekly*, October 24, 1914 and *All-Story Weekly*, June 17, 1916 (both covers by P. J. Monahan). $130-$150 each

The Mucker, hardcover (contains both parts, and is one of the rarest Burroughs titles), McClurg, October 31, 1921 (cover by J. Allen St. John). $3,500-$5,000

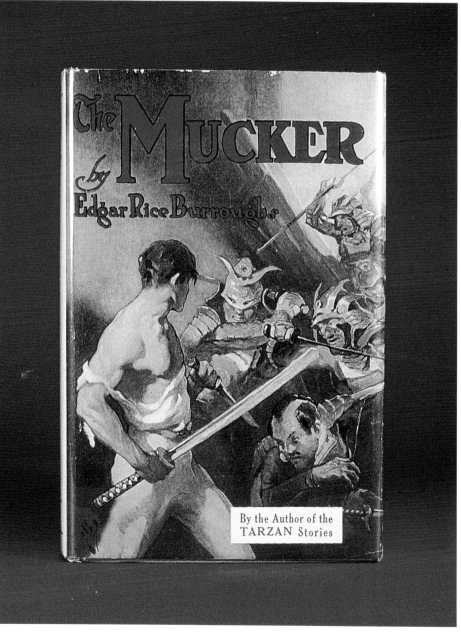

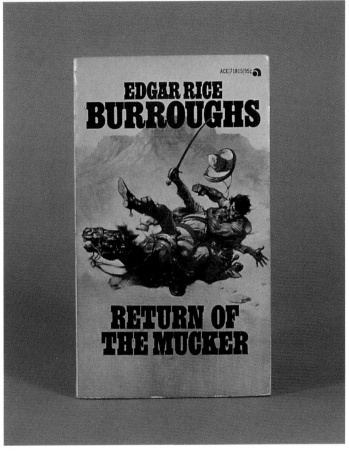

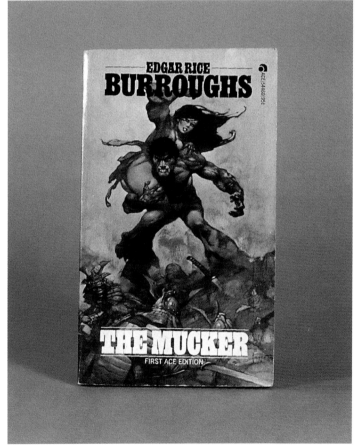

Return of the Mucker, paperback, Ace #71815, undated (cover by Frank Frazetta). $5-$7

The Mucker, paperback, Ace #54460, 1974 (cover by Frank Frazetta). $5-$7

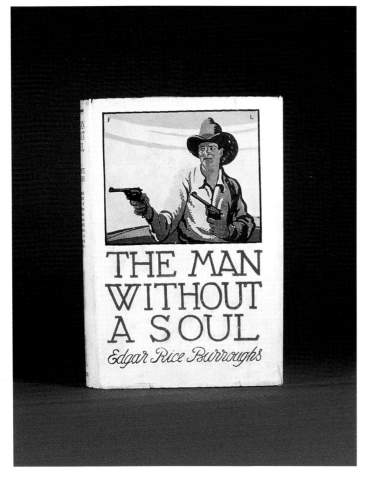

The Man Without a Soul (not to be confused with *A Man Without a Soul*, alternate title of *The Monster Men*), British hardcover, Methuen, January 26, 1922 (no art credit). $350-$500

The Mucker, Russian paperback, 1991 (no art credit). $12-$15

Beyond Thirty, The Lost Continent, The Man-Eater

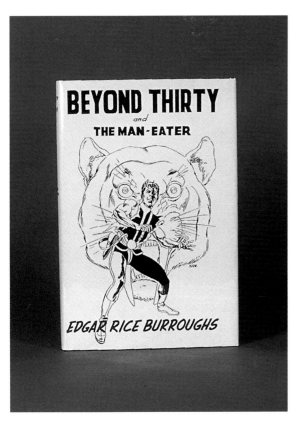

Beyond Thirty & The Man-Eater, hardcover (pulp magazine appearance in *All Around Magazine*, February 1916, no cover), Science Fiction & Fantasy Publications, 1957 (cover by Gilbert Kane). $75-$120

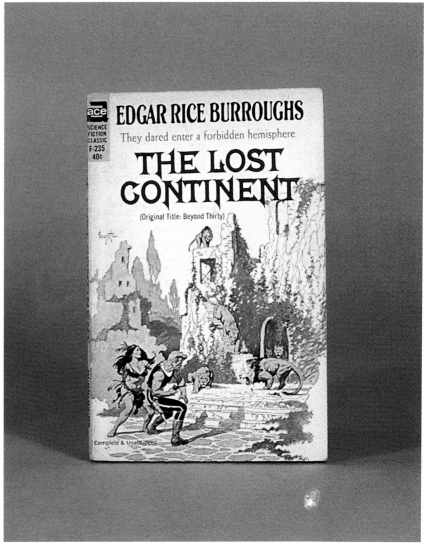

The Lost Continent (alternate title for *Beyond Thirty & The Man-Eater*), paperback, Ace #F-235, undated (cover by Frank Frazetta). $7-$9

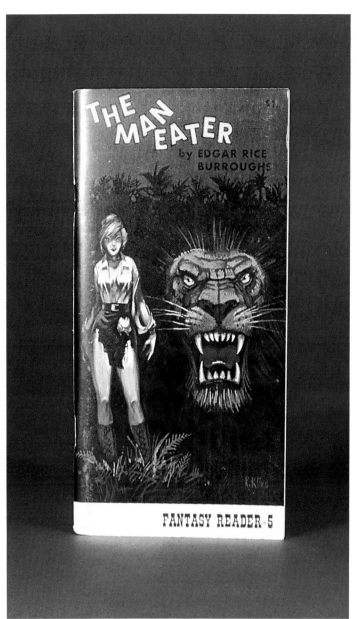

The Man Eater, paperback, Fantasy House, 1974 (cover by Robert Kline). $9-$11

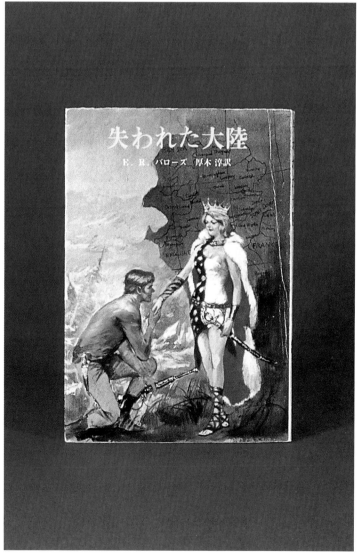

Beyond Thirty, Japanese paperback, Hayakawa, 1974 (cover by Motoichiro Takebe). $9-$11

The Girl from Farris's

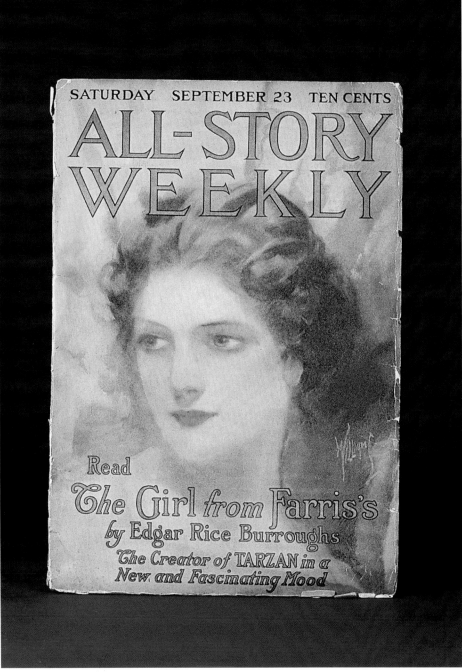

The Girl From Farris's, pulp magazine, *All-Story Weekly*, September 23, 1916 (cover by C. D. Williams). $125-$170

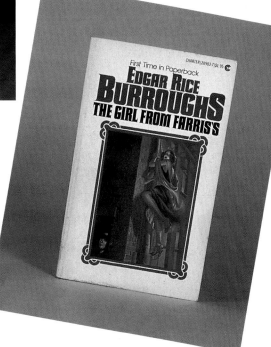

The Girl From Farris's, paperback, Charter Books # 28903-7, 1965 (no art credit). $7-$9

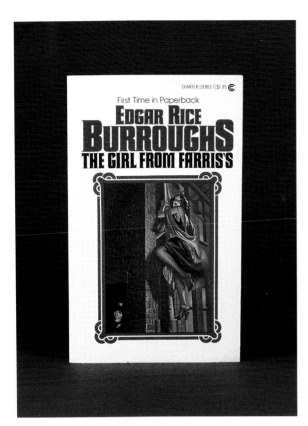

The Girl From Farris's, paperback, Charter, June 1979 (no art credit). $6-$8

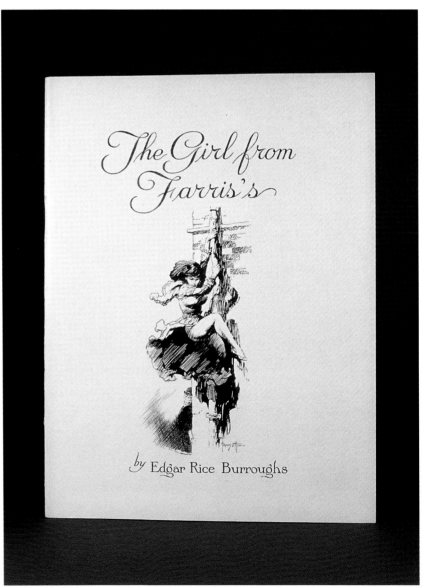

Burroughs Bibliophiles # 59-60 (The Girl From Farris's), fanzine, 1976 (cover by Frank Frazetta). $12-$15

The Lad and the Lion

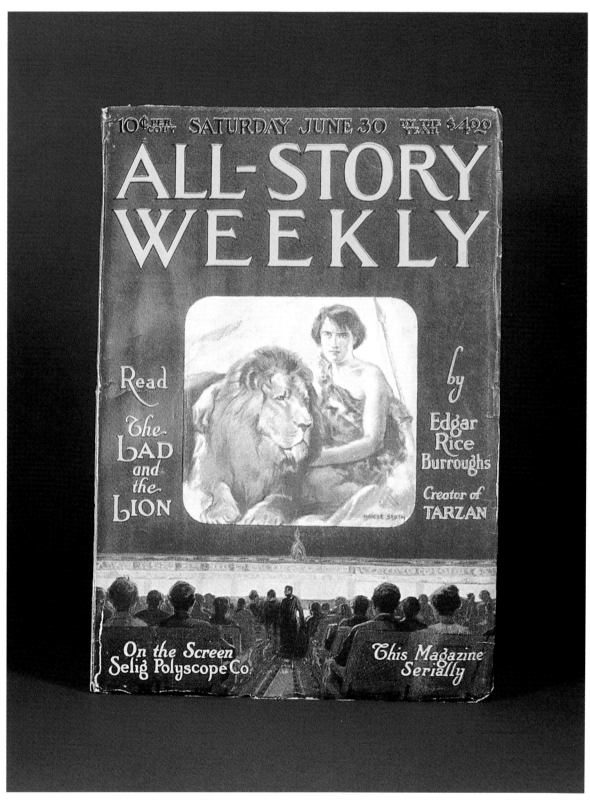

The Lad and the Lion, pulp magazine (note that cover
advertises movie), *All-Story Weekly,* June 30, 1917 (cover by
Modest Stein). $125-$140

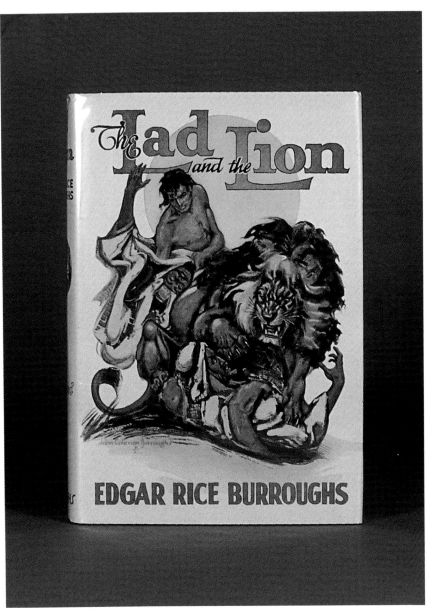

The Lad and the Lion, hardcover, Burroughs, February 15, 1938 (cover by John Coleman Burroughs). $400-$600

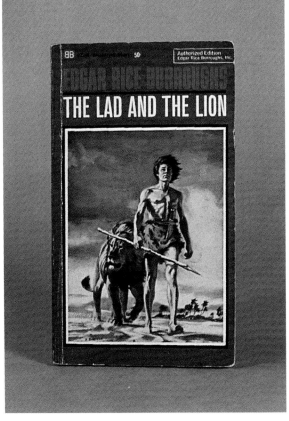

The Lad and the Lion, paperback, Ballantine #U-2048, September 1964 (cover by R. Bartram). $15-$20

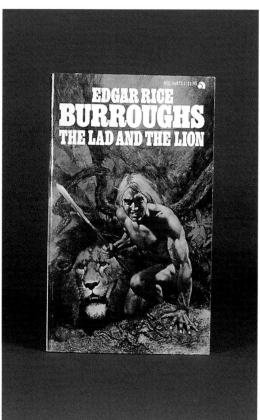

The Lad and the Lion, paperback, Ace #46870, April 1974 (no art credit). $5-$7

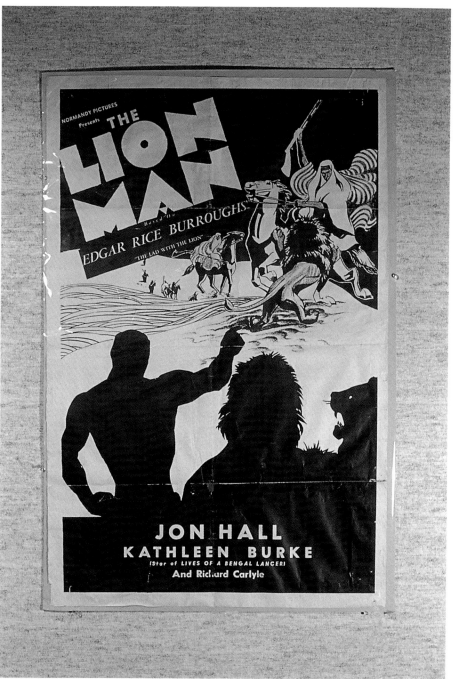

The Lion Man, movie poster (one sheet, 27x41, based on *The Lad and the Lion*), Normandy Pictures, 1937. $75-$125

The Efficiency Expert

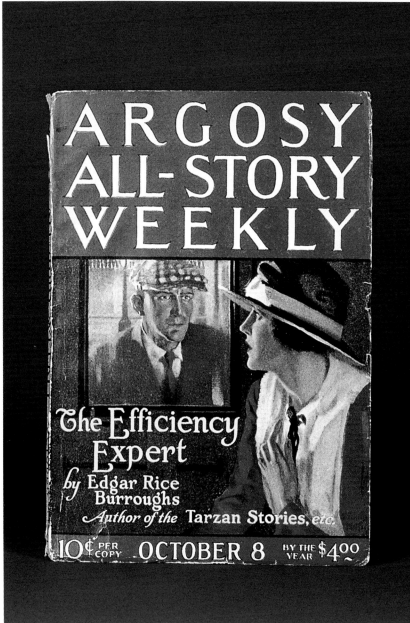

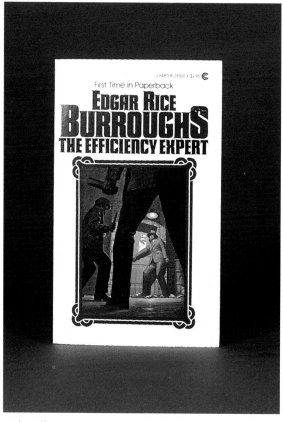

The Efficiency Expert, paperback, Charter, June 1979 (no art credit). $12-$15

The Efficiency Expert, pulp magazine, *Argosy All-Story Weekly*, October 8, 1921 (cover by Stockton Milford). $120-$130

Burroughs Bibliophiles #57-58 (The Efficiency Expert), fanzine, 1976 (cover by Frank Frazetta). $10-$12

The Girl from Hollywood

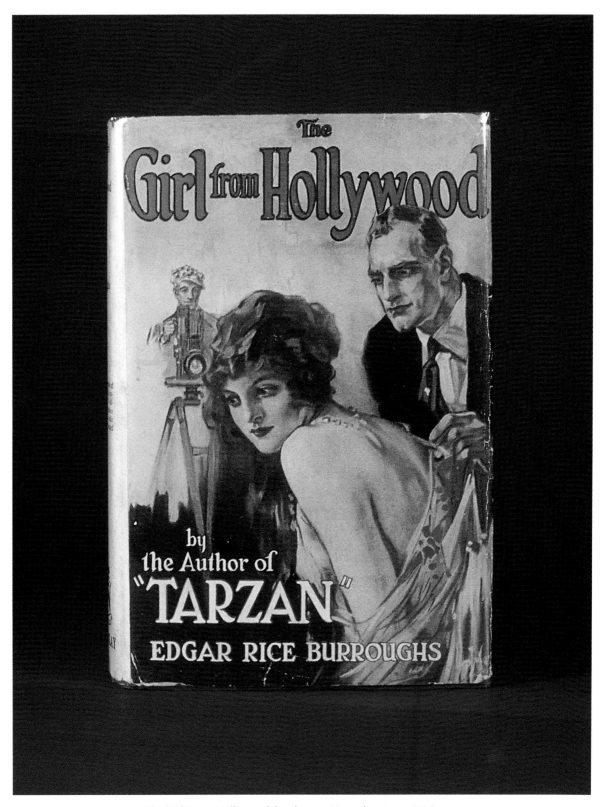

The Girl From Hollywood, hardcover, Macauley, August 10,
1923 (cover by P. J. Monahan). $600-$1,000

Burroughs Bibliophiles #31, fanzine, published by George McWhorter, summer 1977 (cover by P. J. Monahan - repeats cover on first hardcover). $10-$12

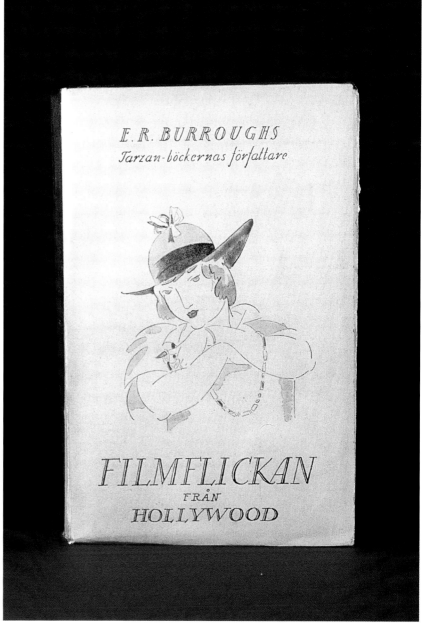

The Girl From Hollywood (FILMFLICKAN FRAN HOLLYWOOD), Swedish paperback, Hockerberg, 1926 (no art credit). $100-$140

The Land of Hidden Men
(Jungle Girl)

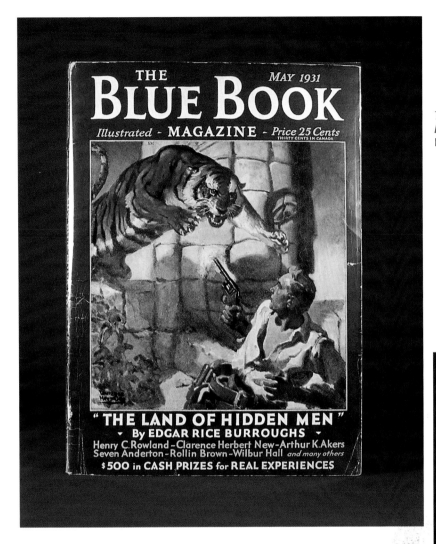

The Land of Hidden Men, pulp magazine, *The Blue Book Magazine*, May 1931 (cover by Laurence Herndon). $50-$60

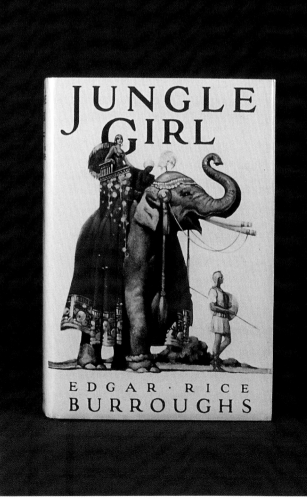

Jungle Girl (alternate title for *The Land of Hidden Men*), hardcover, Burroughs, April 15, 1932 (cover by Studley O. Burroughs). $1,200-$1,600

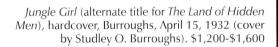

The Land of Hidden Men, paperback, Ace #47012, 1973 (cover by Frank Frazetta). $5-$7

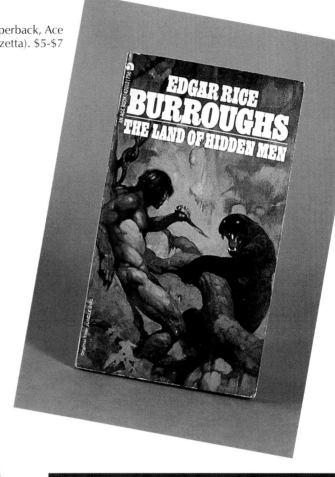

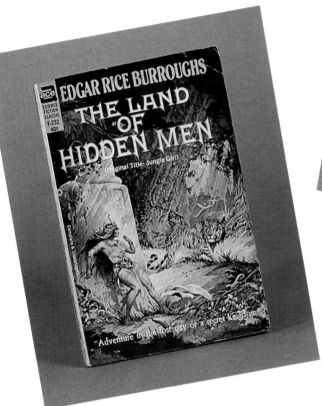

The Land of Hidden Men, paperback, Ace #F-0232, undated (cover by Roy Krenkel). $7-$9

Jungle Girl (HET MEISJE UIT DE WILDERNIS), Dutch hardcover, Graauw, 1950 (no art credit - based on Studley O. Burroughs). $60-$85

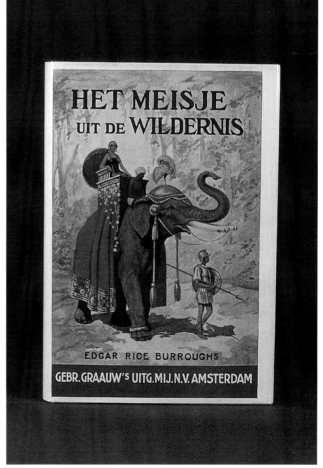

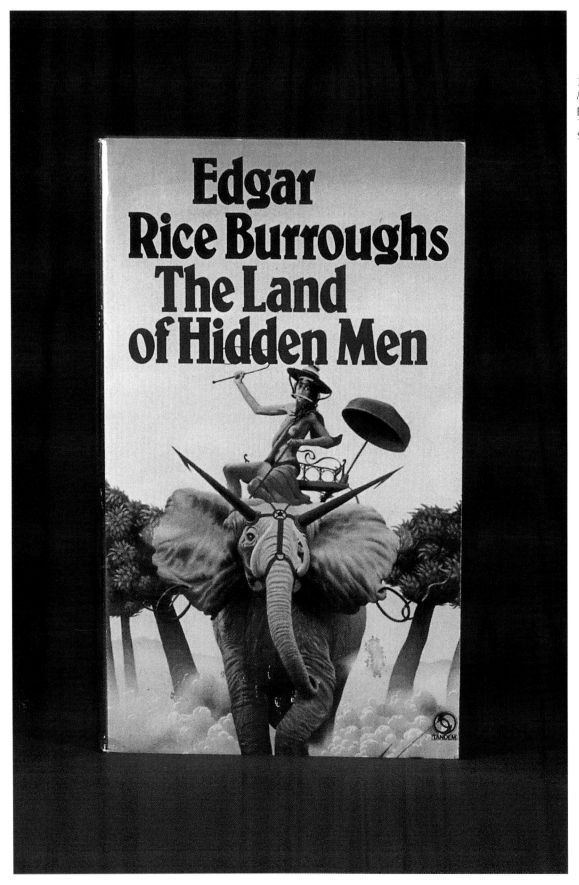

The Land of Hidden Men, British paperback, Tandem, 1976 (no art credit). $4-$6

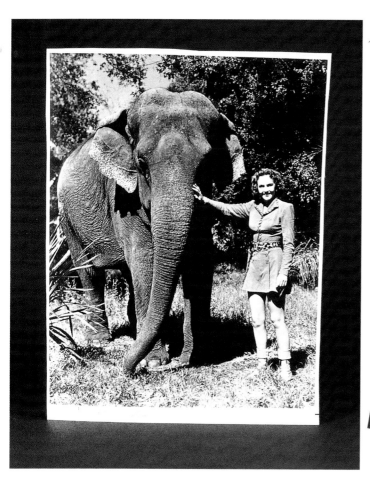

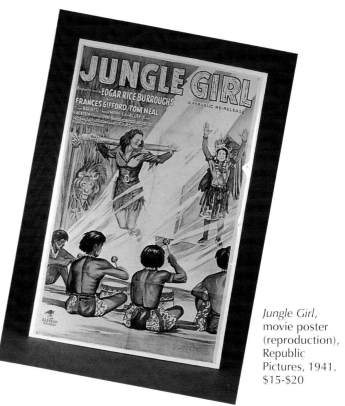

Jungle Girl, b/w movie still featuring Francis Gifford, Republic Pictures, 1941. $10-$12

Jungle Girl, movie poster (reproduction), Republic Pictures, 1941. $15-$20

Minidoka 937th Earl of One Mile Series M

Minidoka 937th Earl of One Mile Series M, limited edition hardcover, Dark Horse Comics, Inc., 1998 (various artists including Edgar Rice Burroughs). $75

Appendix
List of ERB Clubs, Fanzines, and Newsletters (Domestic and Foreign)

The Burroughs Bulletin

George T. McWhorter, Curator, ERB Collection
University of Louisville
Louisville, KY 40292
Issued quarterly
$28 a year

ERB News Dateline

Mike Conran, Editor
1990 Pine Grove Dr.
Jenison, Michigan 49428
Issued quarterly
$12 year

Erbania

D. Peter Ogden, Editor
8410 Lopez Dr.
Tampa, FL 33615
Issued quarterly
$8 a year

ERB-dom

C.E. Cazedessus II, Editor
PO Box 2340
Pagosa Springs, CO 81147-2340
6 issues
$24 a year

ERB-APA

Official Editor
2201 Loreco St. #316.
Bossier City, LA 71112
Limited membership

ERB Collector

Bill Ross, Editor
7315 Livingston Rd.
Oxon Hill, MD 20745

Les Tribune des Amis D'Edgar Rice Burroughs

Michel DeCuyper, Editor
59 Rue de la Filature
59180 Cappelle la Grands
France

ERB Fan

Roland Schwegler, Editor
Eschenweg 5
D-85049 Ingoldstadt
Germany

ERB Notizen

Kurt S. Denkena, Editor
Rosenstrasse 12
D-28755 Bremen
Germany

Fantastic Worlds of ERB

77 Pembroke Rd.
Seven Kings, Ilford
Essex, IG3 8PQ
England